New Bearings

IN

Esthetics and Art Criticism

A STUDY IN

Semantics and Evaluation

BY

Bernard C. Heyl

GREENWOOD PRESS, PUBLISHERS
WESTPORT, CONNECTICUT

TO

F. CUDWORTH FLINT

PREFACE

THE subjects included in the following pages consider what seem to me crucial aspects of artistic analyses. Whether one is an esthetician, an art critic, or an art historian, meaning and evaluation should be major sources of interest. The semantic problems in writings about art have rarely, if at all, been considered, and the problems in evaluation, while by no means new ones, require periodic restatement and discussion. Both types of problems, unfortunately, are major sources of difficulty and confusion.

While the purpose of this book is therefore twofold, I wish to insist that the two parts are connected by more than the common importance of their subjects for artistic analyses. Although the problems concerning semantics are in the main "verbal" ones, and those concerning value judgments are in the main "real," the two sorts frequently interlock and overlap: thus the first half of the book at times necessarily anticipates ontological questions, while the second half at times reverts to linguistic ones. From the very nature of the subjects, that is to say, one set of problems leads naturally to the other, so that, logically, these two approaches to esthetics and criticism should be combined. This conclusion seems inescapable, moreover, from my personal experience: during the past several years, meaning and evaluation have been my leading interests, and a study of one of these topics has regularly involved a study of the other. If one remembers the connections, therefore, between the two kinds of problems, it is not surprising that questions dealt with from one point of view in one part will recur in a different context in the other.

Because of the reciprocal influence upon one another of the two sets of problems, it was not easy to decide which essay should come first and which second. A strong argument for

discussing evaluation first is the dependence of some semantic questions upon philosophical systems; yet, all things considered, it seemed somewhat preferable to tackle the verbal thickets before the ontological ones. The interrelation between the two sets of problems is such, however, that the treatment of one set does not *crucially* affect that of the other; thus a reader who is solely interested in value judgments need not study the semantic issues. The arguments concerning evaluation will stand by themselves.

In the selection of illustrative material, the reason for the relative neglect of art history throughout and for the emphasis upon esthetics in the first part and upon art criticism in the second is a simple one: I wished to use those examples which, wherever they might occur, would best illustrate the arguments. Since art historians tend both to treat material of primarily archeological and historical interest and to consider this material solely in terms of iconographic and stylistic analyses, their writings are of minor significance in the present contexts. Both estheticians and art critics, on the other hand, are deeply concerned with evaluations, and the writings of each raise fascinating semantic questions. In general, however, esthetics offers the most interesting verbal problems, while art criticism seems best to illustrate problems in evaluation. Since this book deals primarily with the current condition of art criticism and esthetics, contemporary examples predominate; but this fact in no way denies the great debt which many modern critics owe to Plato, Aristotle, Longinus, Kant, Hegel, Coleridge, and other writers of the past. Material from literary criticism has been deliberately included in both essays since this criticism, being more fully developed today than art criticism, presents unusually interesting examples of the problems I am considering.

Some readers may resent the length of several of the footnotes. From the standpoint of other readers, however, who are interested only in the linguistic and critical aspects of the

problems discussed, it seemed advisable, on the whole, to cut
down the philosophical argument in the text to a minimum
and to put as much of it as possible into the notes.

Other readers may resent such an extensive use of quota-
tion marks, but where one is dealing so largely with terminol-
ogy and with interpretation of such an "ambiguous" or "re-
sourceful" kind (to use the terms of Dr. I. A. Richards), this
use seems necessary. An alternative procedure, following the
suggestions of Richards in *How To Read a Page*, would be to
use various types of notation to designate the various sorts of
duties which quotation marks perform; but I believe that
Richards' notations are not so easily remembered as he be-
lieves they may be, and that, therefore, they tend to produce
more confusion than they eliminate.

I owe a debt of gratitude to many people. I am thankful,
first of all, to the Trustees of Wellesley College for making
this publication financially possible. I am profoundly grateful
also to the Wellesley College Committee on Publications,
which has given so generously of its time and has recom-
mended that this work be published. And I am greatly in-
debted to a number of friends who graciously consented to
read and criticize earlier versions of the manuscript. For con-
structive suggestions of various sorts I particularly wish to
thank Professors Adele de la Barre Robinson and Edith C.
Johnson of Wellesley College, Professors F. Cudworth Flint
and Philip Wheelwright of Dartmouth College, Professor
George Boas of the Johns Hopkins University, Professor
James Burnham of New York University, and Lieutenant
Franklin Gary, U.S.N.R.

<div style="text-align: right;">B. C. H.</div>

ACKNOWLEDGMENTS

I THANK the many publishers who have kindly given their permission to quote passages from other volumes. George Allen and Unwin Ltd. has permitted me to quote from Howard Hannay's *Roger Fry*, D. G. James's *Scepticism and Poetry*, and Ogden, Richards and Wood's *The Foundation of Aesthetics;* Bryn Mawr College, from *Bryn Mawr Notes and Monographs;* The University of Chicago Press, from Bernard Berenson's *The Drawings of the Florentine Painters*, David Daiches' *The Novel and the Modern World*, John Dewey's *Theory of Valuation*, and C. W. Morris' *Foundations of the Theory of Signs;* The Clarendon Press, Oxford, from R. G. Collingwood's *Principles of Art* and E. F. Carritt's *Philosophies of Beauty;* Cornell University Press, from F. A. Pottle's *The Idiom of Poetry;* Covici, Friede, from *The Journal of Eugene Delacroix;* Thomas Y. Crowell Company, from D. W. Prall's *Aesthetic Judgment;* The John Day Company, from Sidney Hook's *Reason, Social Myths and Democracy;* Ralph T. Hale and Company, from Yukio Yashiro's *Sandro Botticelli;* Harcourt, Brace and Company, from Clive Bell's *Enjoying Pictures*, T. S. Eliot's *Selected Essays*, S. I. Hayakawa's *Language in Action*, Ogden and Richards' *The Meaning of Meaning*, I. A. Richards' *Principles of Literary Criticism*, I. A. Richards' *Coleridge on Imagination*, I. A. Richards' *Interpretation in Teaching*, and Virginia Woolf's *Roger Fry;* Harvard University Press, from S. K. Langer's *Philosophy in a New Key* and C. R. Post's *A History of Spanish Painting;* Henry Holt and Company, from M. M. Rader's *A Modern Book of Esthetics;* Henry Holt and Company and Oxford University Press, New York, from Bertrand Russell's *Religion and Science;* The Johns Hopkins Press, from George Boas' *A Primer for Critics* and Lionello Venturi's *Art Criticism Now;*

The Kenyon Review, from articles by Philip Wheelwright and Eliseo Vivas; Longmans, Green and Co., from William James's *The Meaning of Truth* and C. R. Morey's *Christian Art;* The Macmillan Company, from Benedetto Croce's *Aesthetic as Science of Expression and General Linguistic,* Elisabeth Schneider's *Aesthetic Motive,* Sir Charles Sherrington's *Man on His Nature,* and A. N. Whitehead's *Science and the Modern World;* Coward McCann, from Roger Fry's *Transformations;* New Directions, from J. C. Ransom's *The New Criticism;* W. W. Norton and Company, from Malvina Hoffman's *Sculpture Inside and Out,* I. A. Richards' *How To Read a Page,* and Bertrand Russell's *An Inquiry into Meaning and Truth;* Oxford University Press, London, from Tolstoy's *What Is Art?; Partisan Review,* from articles by John Dewey and Dwight Macdonald; Kegan Paul, Trench, Trubner and Co., Ltd., from I. A. Richards' *Practical Criticism;* The Philosophical Library, from *The Journal of Aesthetics and Art Criticism; The Journal of Philosophy,* from articles by John Dewey and T. M. Greene; Princeton University Press, from T. M. Greene's *The Arts and the Art of Criticism,* F. J. Mather, Jr.'s *Concerning Beauty,* T. C. Pollock's *The Nature of Literature,* and *The Intent of the Critic* (D. A. Stauffer, ed.) ; G. P. Putnam's Sons, from John Dewey's *Art as Experience;* George Routledge and Sons, Ltd., from E. E. Kellett's *Fashion in Literature;* Charles Scribner's Sons, from Henry James's *The Art of the Novel,* J. R. Reid's *A Theory of Value,* George Santayana's *The Last Puritan,* and Leo Stein's *The A-B-C of Aesthetics;* and Edward Arnold and Co., from Sir Walter A. Raleigh's *Style.*

CONTENTS

CONTENTS

PART I

PROBLEMS IN MEANING

"But I am apt to imagine, that, were the imperfections of language, as the instrument of knowledge, more thoroughly weighed, a great many of the controversies that make such a noise in the world, would of themselves cease; and the way to knowledge, and perhaps peace too, lie a great deal opener than it does" (John Locke, *An Essay Concerning Human Understanding*).

"The business of letters, howsoever simple it may seem to those who think truth-telling a gift of nature, is in reality two-fold, to find words for a meaning, and to find a meaning for words. Now it is the words that refuse to yield, and now the meaning, so that he who attempts to wed them is at the same time altering his words to suit his meaning, and modifying and shaping his meaning to satisfy the requirements of his words" (Sir Walter A. Raleigh, *Style*).

"It has been often said in various forms, but hardly ever without truth, that all dispute turns upon difference of definition—and that, if people were only clear-witted enough and even-tempered enough, the arrival at definition would be the conclusion of the whole matter. For their differences of opinion would either disappear in the process, or they would be seen to be irreconcilable, and to possess no common ground on which argument is possible" (George Saintsbury, *Shakespeare and the Grand Style*).

THE FIRST PART of this book aims to show in what ways and to what degree linguistic confusion is responsible for the inadequacy of contemporary art criticism and esthetics. To accomplish this, it will first be necessary to explain, as briefly and simply as possible, the nature of verbal problems, the kinds of confusion which may be caused from a misunderstanding of them, and the correct solutions of these difficulties. Later, I shall illustrate these problems, confusions, and solutions by specific reference to three major terms of art criticism and esthetics: "art," "beauty," and "truth."

I. THE SEMANTIC BACKGROUND

I T is well known that the word "semantics" is used in varying ways and that there are a number of different semantic systems and several types of semanticists. This being so, diversity among premises, aims, and conclusions is to be expected. To illustrate such diversity in only the most recent writing upon semantics, one may observe that whereas Rudolf Carnap in *Introduction to Semantics* strictly limits the field to an analysis of the relationship between verbal expressions and what they designate (i.e., referents, designata, objects, and so forth), and excludes from semantics any consideration of the user of the language, Susanne Langer in *Philosophy in a New Key* holds that the semantic field is wider than that of language, applies the term "semantics" to many kinds of symbolism, and includes in her study not only (*a*) signs and symbols and (*b*) what they designate, but (*c*) the subject who uses the symbols and (*d*) the *conceptions* or *references* which he has of them. My own use of "semantics," as I shall shortly explain more fully, agrees with that of Mrs. Langer except that, in the main, I limit the term to a discussion of verbal matters and mean by it, therefore, *a study of the symbolism of verbal language.*

Before considering what seem to me the basic features of this interpretation of "semantics," I wish to note and comment upon an objection to both semantic methods and ideals which is frequently made by philosophers and by critics philosophically inclined. These writers hold that the semantic view of meaning is too "referential" and insufficiently "organic," in that it tends to seek clarification and precision of meaning above all else, and to stress the separableness rather than the togetherness of words and their significations. It is a view, these philosophers and critics say, which becomes ludicrous

when applied, for example, to poetic attitudes and meanings. Thus Philip Wheelwright is concerned to defend "fullness of context" and "plastic uses of language" and to oppose as "verbal atomism" any tendency to use terms in a restricted and constant sense.[1]

Now in the first place, those semanticists to whose views I subscribe do *not* aim to use words in a restricted and constant sense; and in the second place, far from quarreling with poetic meanings which stress "fullness of context" and "plastic uses of language," these semanticists welcome such meanings. For example, I. A. Richards in his latest book, *How To Read a Page,* lays particular emphasis upon the "versatility" and "resourcefulness" of words, stressing not only the existence but the efficacy of their varied and multiple meanings. Most semanticists claim, however, that when, as is the case with esthetics and a... criticism, adequate understanding and satisfactory communication largely depend upon precision of meaning, then, surely, a leaning toward exactitude rather than toward richness and vagueness of language is preferable. And most semanticists claim, further, that philosophers and philosopher-critics ignore at their peril the basic principles of semanticism set forth in the following pages.[2]

One may succinctly explain the most important aspects of the relationship between words and things, between linguistic machinery and non-verbal facts, by first distinguishing symbols from signs.

1. See "Poetry and Logic," *The Symposium,* October, 1930; and "On the Semantics of Poetry," *The Kenyon Review,* Summer, 1940.

2. It is not really surprising that philosophers tend to be hostile toward the semantic point of view about to be considered; for it is said with reason that a comprehension of this semantics will render much metaphysical speculation futile, since many historic philosophical questions become, in the light of semantic studies, artificial questions to which no true or false answers can be given because their solutions depend, not upon matters of fact, but upon matters of language. An instructive example of this effect of semantics upon philosophy is the compelling argument of A. J. Ayer (*The Foundations of Empirical Knowledge* [New York, 1940]) that the philosophical "argument from illusion" is, at bottom, a verbal problem.

A sign indicates the existence—past, present, or future—of a thing, event, or condition. Wet streets are a sign that it has rained. A patter on the roof is a sign that it is raining. . . . The logical relation between a sign and its object is a very simple one: they are associated, somehow, to form a *pair;* that is to say, they stand in a one-to-one correlation.[3]

Symbols, on the contrary,

are not proxy for their objects, but are *vehicles for the conception of objects.* To conceive a thing or a situation is not the same thing as to "react toward it" overtly, or to be aware of its pres- ʾce. In talking *about* things we have conceptions of them, not ḍhe things themselves; and *it is the conceptions, not the things, that symbols directly "mean."* [4] . . . The fundamental difference between signs and symbols is this difference of ' ʾsociation, and consequently of their *use* by the third party to the meaning function, the subject; signs *announce* their objects to him, whereas symbols *lead him to conceive* their objects. The fact that the same item—say, the little mouthy noise we call a "word"—may serve in either capacity, does not obliterate the cardinal distinction between the two functions it may assume.[5]

Now semantics, according to my definition, has to do with symbols, not with signs. It is evident from the foregoing paragraph, therefore, that semantics is a complex affair in which

3. S. K. Langer, *Philosophy in a New Key* (Cambridge, Mass., 1942), p. 57. Mrs. Langer's analysis of our present semantic problem is the most skillful one known to me.

ʾ. 4. One constantly uses the word "mean" in various ways. Thus in a psycho- ʾogical sense, a person may "mean" some referent (i.e., some object or state of affairs) by a term; or in a logical sense, a term may "mean" some referent to a person; or again, as in the quotation just cited, terms may "mean" *conceptions* of some referent to a person. In this book I do not aim at consistency in the use of this tricky word "mean," but rather hope that its uses will be sufficiently clear from their context. When speaking of the "meanings" of words, I am usually referring to both the referents and th conceptions (i.e., to both the denotations and the connotations of words).

5. Langer, *op. cit.,* pp. 60–61.

four essential factors are involved: the subject, the symbol, the referent, and the conception. Let us now clarify the relationship between three of these factors by the following well-known triangular diagram.

CONCEPTION

(reference, connotation, psychological response, attitude or state of person hearing or speaking, thought, idea, etc.)

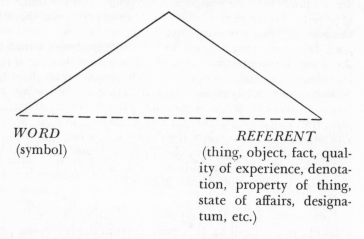

WORD
(symbol)

REFERENT
(thing, object, fact, quality of experience, denotation, property of thing, state of affairs, designatum, etc.)

This diagram indicates (*a*) that the relationship between words and referents, which we shall call *denotation,* is an indirect or imputed one, and (*b*) that the relationship between words and conceptions, which we shall call *connotation,* is a direct one. As Coleridge delightfully explains:

It is the fundamental mistake of grammarians and writers on the philosophy of grammar and language, to suppose that words and their syntax are the immediate representatives of *things,* or that they correspond to *things.* Words correspond to thoughts, and the legitimate order and connection of words, to the *laws* of

thinking and to the acts and affections of the thinker's mind. . . .
Read this over till you understand it.[6]

Thus words are not a mere mirror or reflection of the non-
linguistic world; they are not, as Plato seems to suppose, true
or false likenesses and images of the things which they name;
as symbols, they do not "mean" unless a third component of
semantics—conception—is present; they have no direct, one-
to-one connection with facts. Since, therefore, a cleavage exists
between symbols and things symbolized, we cannot justly
say that words have any single "real," "right," "correct,"
"proper," "ultimate," or "true" meanings. Indeed diction-
aries, which some might suppose could refute this claim that
words have no such meanings, in fact support it in their his-
torical record of the many senses which words have had and
continue to have. In short, as Welby says: "There is, strictly
speaking, no such thing as the Sense of a word, but only the
sense in which it is used—the circumstances, state of mind,
references, 'universe of discourse' belonging to it." [7] This be-
ing so, a remark like the following by an eminent teacher
seems absurd: "What I have described as inspiration, em-
bodies itself in what is the only true sense of the word 'style';
conception, in the only true sense of the word 'form.' " [8]

To be sure, symbolic uses of words differ considerably in
the degree of precision and directness with which they desig-
nate referents. At one extreme, affective or emotive language
(interjections and exclamations for instance) *primarily* ex-
presses the state of the speaker or affects the feelings of the
listener or reader. Such language is essentially, if not wholly,
connotative and is only secondarily concerned, if at all, with

6. "Letter to James Gillman," 1827, quoted by I. A. Richards, *Coleridge on
Imagination* (New York, 1935), p. 122.
7. V. Welby, *What Is Meaning?* (London, 1903), p. 5.
8. Roger Sessions, "The Composer and His Message," *The Intent of the
Artist* (Princeton, 1941), p. 127. Augusto Centeno, ed.

reporting any external state of affairs; the conceptions, not the referents, are accented. At the other extreme, conceptions symbolized by simple, basic words like "red" and "go"— Bertrand Russell's "object-words"—are directly derived from the referents themselves: "Their meaning is learnt (or can be learnt) by confrontation with objects which are what they mean, or instances of what they mean." [9] In such cases, the *denotative* relationship between words and referents is accented. But these "object-words" are not—unfortunately, perhaps—the important terms of esthetics and art criticism.

Indeed, all of the words which concern the esthetician and critic most deeply have acquired their meanings in a far less simple fashion than "by confrontation with objects." Terms like "beauty," "art," "esthetics," "judgment," "value," "quality," and so forth have never stood for specific referents, but have rather been a part of a series of contexts, the meanings of which are constantly shifting to a greater or smaller degree. Nor is this shifting remarkable when we remember the indirectness of the semantic relationship, and the general and abstract character of the words in question. In the case of words of an adjectival character, moreover, an exceptional degree of shifting occurs for the following reason:

Whenever we employ a word we at least implicitly intend, purpose, or mean *two* things: not the thing-meant alone, but also as much of the word-meaning as is applicable to the thing-meant. . . . A meaning is said of a thing-meant; but the listener may be induced to stop at the meaning, in which case the thing-meant, though still there, fades into momentary insignificance.[10]

Now this latter situation occurs with a word like "beauty," which is distinctly adjectival. We use the word not primarily

9. Bertrand Russell, *An Inquiry into Meaning and Truth* (New York, 1940), p. 28.

10. A. H. Gardiner, *The Theory of Speech and Language* (Oxford, 1932), p. 257.

to stand for some referent or thing-meant, but as an attribute of something to be explained by the situation or another word. Thus, this and all similar words have a peculiarly flexible and variable nature, and the senses of such words are even less pinned to specific referents than are those of other sorts of words. In short: variation in the meanings of esthetic and critical terms is the rule, not the exception. If we recognize this fact sufficiently, we should not be surprised by a remark like that of Richards that "until recently Oxford-trained men and Cambridge-trained men hardly ever understood one another on any abstract topic—because their key explanatory words turned in different locks." [11] The opening words of Richards' sentence—"until recently"—are reassuring, yet it is highly doubtful whether the improvement they indicate can likewise be found in the bulk of supposedly educated discussions upon art and beauty in America.

The difficult semantic situation I have sketched should lead no one to adopt, however, the desperate extreme of Mr. Stuart Chase who, in his popular book *The Tyranny of Words*, contends that since abstract and general terms have no fixed and exact meanings and are therefore treacherous, one may as well substitute "blab-blab" for each of them. No; it is not necessary, perhaps not even desirable, to use these "fictional" or "wandering" words less, but rather to adopt toward them a different attitude: to treat them not as entities but as metaphors which need frequently to be translated "into concrete terms which hold fewer possibilities of difference of opinion." [12] They should be studied, not eliminated.

Closely allied with and partly dependent upon the false notion that a one-to-one or direct relation exists between words and referents is the equally false notion—and this is perhaps the chief misconception leading to semantic befud-

11. I. A. Richards, *Interpretation in Teaching* (New York, 1938), p. 348.
12. Hugh Walpole, *Semantics* (New York, 1941), p. 171.

dlement—of the validity of what semanticists call "real" or "metaphysically realistic" or "quasi" definitions. These are definitions which pretend to reveal the "true nature," "ultimate characteristic," "whatness," "Essence," or "Reality" of their referents.

The reasons given in support of this type of definition, which I shall henceforth call a "real definition," appear to be of three interconnected, perhaps overlapping sorts: (a) a conviction (which has already been spoken of and which any dictionary would explode) that only one true or proper referent for a word exists; (b) a vague but firm contention that words are in fact something more than words, i.e., a "type of reaction which somehow sees in the words themselves the very 'things' which the words are intended to represent";[13] and (c) an "organic" view of semantics which repudiates the "referential" view indicated by the triangular diagram and which supposes that words and their referents can be so fused that the words will simultaneously define and say something significant about these referents—a supposition which I shall consider a few pages farther on.

Since semanticists have challenged at length these notions supporting the value and legitimacy of real definitions, it is only necessary, for my purpose, to touch upon the main arguments in their refutation. In the first place, it is manifestly impossible to comprehend anything fully and completely, for however much one may know and say about any referent, one is always "abstracting" certain properties and omitting others. "Evidently complete knowledge of anything, if we include all its natural and ideal relations, is incompatible with mortality and with the biological basis of thought."[14] It follows that, *pace* Plato and many other philosophers, nothing can be known "as it really is," and that language cannot therefore in

13. I. J. Lee, *Language Habits in Human Affairs* (New York, 1941), p. 131.
14. George Santayana, *Obiter Scripta* (London, 1936), p. 100. J. Buchler and B. Schwartz, eds.

any form reveal a total Essence or Reality. An entertaining paragraph by Richards may clarify this important idea:

Suppose someone asks, "What is an apple?" Our answer might be, "It is a fruit that grows on a tree." To which he might reply, "I was not asking you where it grew; I was asking you what it is." We try again, "It is a refreshing fruit." He replies, "I was not asking you what it was like or what it did; I was asking you what it is." Suppose we say, "It is an assemblage of cells, a system of molecules, atoms, etc." He can always reply, "I was not asking you what I should see if I took a microscope to it or what chemical hypothesis would explain what would happen to it if we did certain things to it, etc. I was asking you, quite simply, what it is?" In this way, he has us beaten from the start. We can only dispose of him by saying that his question is illegitimate, and that, if we define a question as something that theoretically can have an answer, his demand is not a question. It is only supposed to be one by having the same verbal form as some things which are questions and so, theoretically, can be answered.[15]

In the second place, not only are words unable to reveal the total Essence or Reality of anything; they cannot even reveal, I think, any special qualities which are the "true," "real," or "essential" ones; for, as Mrs. Langer says: "There is, in fact, no such thing as *the* form of the 'real' world; physics is one pattern which may be found in it, and 'appearance,' or the pattern of *things* with their qualities and characters, is another. One construction may indeed preclude the other; but to maintain that the consistency and universality of the one brands the other as *false* is a mistake." [16] If this is so, "Is there any conceivable way of determining what *are* the essential properties of a thing? Is it not obvious that judgments purporting to set forth the so-called essential properties of a thing

15. *Interpretation in Teaching,* p. 354.
16. *Op. cit.,* p. 91.

vary with the knowledge, the interests and the purposes of the definer?" [17] Of course many philosophers will deny the implications in these questions on the basis of absolutist convictions. Reason or intuitive insight, they will say, *can* reveal true or essential qualities. Thus arises a non-verbal, philosophical argument which will be mentioned later on in this book. At this stage of our discussion we may merely observe the interesting connectedness between verbal and ontological problems.

And in the third place, finally, both the foregoing explanation that most words—and certainly the crucial terms of esthetics and criticism—acquire varied meanings from being involved in different contexts, and the illustration by means of the triangular diagram of the indirectness of the relation between words and their referents should make it apparent that, for semantic reasons, real definitions can have no intelligible meaning. Denial of this conclusion is the result partly of insufficient understanding of semantics, partly of erring metaphysics. But whatever the reason may be, writings upon esthetics and upon art and literary criticism offer the depressing spectacle of authors attempting to teach what a poem or a picture, what art or beauty *is*, to reveal, that is to say, its ontological nature. Thus J. C. Ransom urges that the intent of the critic (or a portion of it) "is to read and remark the poem knowingly; that is, with an esthetician's understanding of what a poem generically 'is'." [18]

But if real definitions are a major source of semantic confusion in esthetics and criticism, another sort of definition offers a major solution for our problem. I refer to definitions which have been called "volitional," "intentional," "nomi-

17. J. R. Reid, *A Theory of Value* (New York, 1938), pp. 6–7.
18. "Criticism as Pure Speculation," *The Intent of the Critic* (Princeton, 1941), p. 94. D. A. Stauffer, ed. That the concluding "is" in Mr. Ransom's statement refers to some ontological Essence or Reality may fairly be deduced from the whole tenor of his critical writings.

nal," "arbitrary," "acting," and "empirically descriptive." As these various adjectives suggest, such definitions differ both from conventional, dictionary ones which, by providing verbal synonyms, report or explain the meanings words already have been given, and from real ones which purport to convey the Essence of something. Volitional definitions, in brief, are arbitrarily chosen means of describing an object, quality, situation, relation, and so forth. Most words, *up to a point*, may mean what we wish to have them mean; we can therefore volitionally define them, intending by our definitions simply proposals for a working agreement in the use of certain terms. "Let us agree that by 'art' we will mean such and such." In this procedure, which contrasts with those of making both dictionary and real definitions, we are primarily *giving* words meaning, not searching for meanings in them. Thus, for vivid contrast with Ransom's remark quoted in the preceding paragraph, consider these wise words of Henri Focillon: "The critic will define a work of art by following the needs of his own individual nature and the particular objectives of his research." [19]

By pointing next to a major distinction between *volitional definitions,* on the one hand, and *propositions,* on the other, we can throw further light upon *real definitions* and, at the same time, reveal the ambiguous character of that organic view of meaning which so strongly advocates the validity of these real definitions. Volitional definitions, in contrast to propositions (or to statements and judgments), are about language; they define words, not things; they do not assert facts, and hence do not raise issues of truth and falsehood. Such a definition "is not true or false, being the expression of a volition, not of a proposition." [20] Propositions, on the contrary,

19. *The Life of Forms in Art* (New Haven, 1942), p. 1. C. B. Hogan and George Kubler, trans.
20. Whitehead and Russell, *Principia Mathematica* (Cambridge, Mass., 1910), I, 11.

are true or false, inasmuch as the meanings of their terms are (or should be) already known; but this situation in the case of volitional definitions does not confront one. This contrast between volitional definitions and propositions—and a similar contrast might be made between dictionary definitions and propositions—is of first importance in semantics; for truly, as Richards asserts, "The great snare of language . . . is the confusion between a *definition* [by which he of course refers to a volitional one] and a *statement that is not about the use of words."* [21] While a hard and fast separation between these categories is, doubtless, neither possible nor desirable in ordinary discourse, a careful distinction between them is essential to the more specialized kind of analysis required in discussions of beauty and art. Unfortunately this distinction is ignored or blurred by writers who give us the hybrid category of real definitions which may now be more clearly seen as misguided efforts—which are perhaps conscious, perhaps unconscious—to straddle the alternative possibilities of volitional definitions and of propositions in an attempt simultaneously to define terms and to state truths.

In the following section of this part I shall attempt to illustrate specifically the point that an ability to recognize the virtues of volitional definitions and the vices of real definitions is a principal method of understanding and so of eliminating semantic confusion. Before doing this, however, I am anxious to anticipate the likely objection that I am exaggerating the importance of volitional definitions. Not wishing for an instant to claim that such definitions can be a complete cure for

21. *Interpretation in Teaching,* p. 253. In *How To Read a Page* (New York, 1942), p. 167, Richards comments upon the same problem in this way: "The writers usually wobble every bit as much as their readers between naming something with their sentences and saying something about some other thing. . . . But we suppose them (and they suppose themselves) to be laying down an alleged truth about something which is set up otherwise. Whence most of our intellectual woe. Any training we can give ourselves, any techniques we can develop for handling this prime shift, will be illimitably rewarding."

all semantic ailments, I shall indicate two significant limitations in the application and usefulness of them.

(a) The necessity for and the nature of volitional definitions by no means imply that any one definition is as satisfactory as any other; for while a word has neither a "true," "single correct," nor "essential" meaning, words are not *wholly* conventional; they do "apply to *groups* of similar situations, which might be called *areas of meaning*." [22] For this reason, we remarked earlier that, *"up to a point,"* we may give meanings to words. Thus, while definitions may be arbitrary in the sense of being deliberately chosen, they must never be unnecessarily or excessively arbitrary; for even if they cannot reasonably be considered true or false, they may certainly be considered sensible or foolish. The meanings of words, in short, should be "waringly and sparingly" altered since, to quote Locke, "He that applies his names to ideas different from their common use, wants propriety in his language, and speaks gibberish." [23] Since this is so, I suggest that there are certain general criteria of good volitional definitions which may be summarized in the words of J. R. Reid: the definitions should be " (1) clear and intelligible, (2) as convenient or useful as possible in dealing with a given subject-matter, and (3) should as nearly conform to established usage, if any, as is compatible with clarity and usefulness in the context." [24] We shall have occasion to refer frequently to these criteria.

(b) Most of the time we necessarily rely upon "established usage" in order to express our meanings; for while usage does not *permanently* *fix* the meanings of words, it does largely regulate the verbal customs which enable us to communicate with one another.[25] And in the last few centuries, dictionaries

22. S. I. Hayakawa, *Language in Action* (New York, 1941), p. 71.
23. "Of Words," *An Essay Concerning Human Understanding* (Oxford, 1894), II, 144. A. C. Fraser, ed.
24. *A Theory of Value*, p. 25.
25. In *Interpretation in Teaching*, chaps. xv and xvi; in *The Philosophy of Rhetoric*, lecture iii; and in *How To Read a Page*, chap. iii, Richards

have become the great repositories of "established" or "good" usage, so that dictionary definitions are of course extraordinarily helpful. Moreover, one would never dream of defining volitionally most of the words we use. Would it not be an incredibly awkward, indeed an impossible task, to give each word a volitional definition before using it? Yet without doing this, we manage for the most part to understand each other well enough.

A recognition of the importance of usage, however, has a minimum of bearing upon the crucial terms of esthetics and art criticism because, as we have seen, the meanings of these terms—in contrast, say, to terms which designate common objects or common acts—are exceptionally unfixed and unstable. Consider in this connection not only those words already mentioned ("art," "beauty," "truth," "esthetics," "judgment," "value," and "quality"), but the following: "objectivism," "subjectivism," "realism," "naturalism," "classicism," "romanticism," "form," "content," "representation," "rhythm," "style," and so on. All of these words are constantly receiving multiple definitions, so that any attempt to find a single precise and preferred usage for them would be in itself a tremendous, if not a hopeless task, and its outcome, because inevitably tentative, would prove to be historically interesting rather than practically fruitful. If, on the other hand, volitional definitions are made the essential preliminaries for further discussion, the critical problem at hand is immediately simplified and clarified.

In the opening chapter of his volumes upon the history of Spanish painting, Professor Post admirably illustrates this correct semantic procedure in his definitions of those much abused words "realism" and "naturalism." He proposes sepa-

thoroughly attacks the so-called "doctrine of usage." It is not necessary for my purpose to consider the pros and cons of this much argued question of usage, but it is at least worth pointing out that the discussion hinges to no little degree upon the exact sense in which the word "usage" is used.

rate meanings for the two terms and he introduces his differentiation with the following sensible statement: "In making such a distinction I do not claim to be establishing definitions that will be valid for other students, nor am I concerned with maintaining the distinction against objections. The intention is merely to make a perfectly arbitrary differentiation of naturalism and realism for the sake of present exigencies." [26] That his ensuing definitions are not *excessively* arbitrary, however, appears from his next sentence: "I have not reached my conclusion, however, without a careful analysis of the ideas conveyed to my own mind by the words and, so far as possible, of the connotations attached to them, consciously or unconsciously, by the majority of discriminating writers." The distinction between naturalism and realism then follows and the paragraph concludes with these words: "In thus seeking to limit realism for the purposes of this book, no effort has been made to take into account such esoteric and, if you will, possible definitions as an application of the term to works of art that render the essence, though not necessarily, the outward semblance of the thing." [27] This last remark is exceptionally interesting for our present linguistic problem when we consider it in conjunction with the following very different pronouncements upon realism of Professor Morey: (i) "The realist is one who grips the concrete, but at the same time by intuition grasps the universal significance that it implies";[28] (ii) a French Gothic statue in the Princeton Museum is "realistic in the best and *ultimate* sense because it reveals through its lovely homeliness the fundamentals of human character and emotion" [29] (my italics). These quotations indicate that Morey does not always recognize the need of volitional defini-

26. C. R. Post, *A History of Spanish Painting* (Cambridge, Mass., 1930), I, 17.
27. *Ibid.*, p. 18.
28. C. R. Morey, *Christian Art* (New York, 1935), p. 46.
29. *Ibid.*, p. 61.

tions; for he informs us, by means of a real definition, what realism *is;* and his real definition, be it observed, is identical with the meaning which Post, after carefully studying the connotations attached to "realism" "by the majority of discriminating writers," considers "esoteric"!

In concluding this summary analysis of certain major semantic problems, one may say that the general method used in solving these problems is one of "interpretation." Thus the remainder of this essay attempts to interpret correctly various uses—some legitimate, some illegitimate—of the words "art," "beauty," and "truth." While no semanticist will question the need of such interpretation, others will say that much ado is being made about very little. Is not the complexity of critical interpretation, some may ask, grossly exaggerated? A few pages from Dr. Richards' *Mencius on the Mind*—or, indeed, pages from any of his books—should convince one to the contrary. To be sure, one might expect interpretative difficulties to be formidable when analyzing the meanings of Mencius, a Chinese writer of the fourth century B.C.; but *how* formidable they are can only be appreciated by learning that fundamental cleavages in mental constitutions probably exist between Mencius and ourselves.[30] More impressive, perhaps, because more immediate to us, is Richards' demonstration of the "linguistic disability" of T. S. Eliot to grasp any of the "superfluity of meanings" in Keats's "Beauty is truth, truth beauty." [31]

Still other opponents of the semantic procedure followed in

30. Cf. the following sentences of Sir Charles Sherrington: "Kant seems to assume the human mind to be a finished thing, a completed item of existence. But the human mind is part of a tide of change which, in its instance, has been latterly and, we may think, still is, running like a mill-race. Living things are all the time busy becoming something other than what they are. And this, our mind, with the rest. It is being made along with our planet's making. We do not know that it ever will be finished" (*Man on His Nature* [New York, 1941], p. 169).

31. *Mencius on the Mind* (New York, 1932), p. 117.

this essay will suggest: are not the meanings of words sufficiently clear from their context? And if so, why bother about these distinctions between definitions, propositions, and so forth? Now, although those who ask such questions are probably suffering from the "illusion of exact communication," everyone will nonetheless agree that the importance of learning the meanings of words from their context is indubitably great. Richards' *How To Read a Page* shows above all else, perhaps, how words acquire different meanings through their complex associations with each other. Doubtless, too, because of their context, words sometimes have the power to communicate the meanings desired even if they are used in a theoretically bad manner. Such facts, however, in no way invalidate the significance of all sorts of interpretation. Study of context, of course, *is* a method of interpretation; and it will frequently be used in this book. But there are other methods which are of equal value in understanding the meanings of estheticians and art critics; and these are the methods which have been stressed in the foregoing pages and which will occupy a major portion of the discussion which follows.

II. "ART" AND "BEAUTY"

IN art criticism and esthetics the words "art" and "beauty" are interwoven in such a way that they can be most interestingly and profitably considered together; for in the first place, art and beauty are the two central components of esthetic theory; in the second, discussion of one of these terms usually involves the other; and in the third, the meanings of the terms—both connotative and denotative—frequently overlap. Furthermore, since the linguistic problems in each case are markedly alike, they can best be analyzed by using both terms as illustrations of the points to be made. An exhaustive historical account of the uses and abuses of either word would be decidedly instructive, but that would be necessarily a very long story and, inevitably perhaps, tedious. My purpose, then, is not to discuss a single term fully, but rather to indicate by specific references to a number of uses of "art" and "beauty" some prevalent verbal confusions.

But first it will be helpful to pose a problem which is primarily ontological rather than verbal: namely, to what extent may one say that the diversity of meanings given to the words "art" and "beauty" is proof of an equal diversity of esthetic sensitivity—which is, after all, the main factor in assigning meanings to these words? In other terms: may one reasonably assert that degrees of esthetic sensitivity account for the diversity of meanings we are about to consider? The question might be raised by an analysis of any such more limited critical or esthetic problem as the following: is esthetic experience inextricably bound up with experiences of ordinary practical life or is it a separate and isolated phenomenon?

In solving such problems, I should first rule out the solution indicated by the following quotation, which claims that linguistic differences in esthetics are purely terminological in

that they do not reflect genuine differences in experience: "Those who find a contradiction among aesthetic theories have simply not taken the trouble to grasp the gist of each theory, and assume that a difference in terminology also represents a different conception of the nature of that to which the terminology refers." [32] While I heartily concur that a more searching interpretation of meanings may explain away as verbal differences *some* esthetic disagreements, to suppose that no esthetic contradictions exist seems patently false. Can one seriously contend, say, that the multiple debates concerning the place of cognition in esthetic experience are only and always disputes over different uses of the word "cognition"? An affirmative reply to this question would contradict much available evidence. For example, a juxtaposition of two quotations, one from a poet-critic, the other from a painter-critic will show that basic esthetic disagreements *do* exist among expert sensitivities. J. C. Ransom writes: "Art feels not hot but cool; . . . art in its reconstructions arranges matters so that, however it may have been in actual life, here the passion will not dominate the cognition; . . . art is among the highly reflective or cognitive activities, not recognizable when cited for its effectiveness as a mode of passion." [33] But Matisse says: " 'I think only about rendering my emotion. Very often, an artist's difficulty lies in his not taking into consideration the quality of his emotion, and in the fact that his reason misleads this emotion.' " [34]

Any further conclusions regarding this major preliminary problem of the relationship between esthetic sensitivity and the meanings given to "art" and "beauty" will depend in large measure upon one's philosophical position. Thus for an absolutist, qualities of experience are arranged according

32. Max Schoen, "Aesthetic Experience in the Light of Current Psychology," *The Journal of Aesthetics and Art Criticism*, Spring, 1941, p. 30.
33. *The New Criticism* (Norfolk, Conn., 1941), p. 16.
34. Quoted by Lionello Venturi, *Art Criticism Now* (Baltimore, 1941), pp. 17–18.

to a fixed hierarchy of values, so that one and only one explanation of an experience is valid. For a relativist, however, important differences exist among esthetic experiences because of innately differing although equally valuable and sensitive psychological constitutions, so that diverse explanations of these experiences may be equally sensitive and valid (though this relativist view does *not* imply that *all* explanations are equally sensitive and valid). Therefore according to relativism, which is the position accepted by the writer, each of the differing theories about art and beauty I am about to mention is competent and intelligent. If this is so, such semantic considerations as multiple definitions and the technique of translating meanings into other terms become exceptionally interesting, intricate, and important.

(A) Multiple Meanings

WITHOUT investigating, for the moment, the precise semantic situation manifested in the variations in opinion, I shall illustrate the diversity of interpretation which has been given to the words "art" and "beauty" (or to the qualities of experience, *art* and *beauty*, if the writers, as is usually the case, are attempting rather to explain referents by propositions or real definitions than to define symbols arbitrarily). Two striking ways of realizing this divergence in esthetic attitudes are to inspect the multiple definitions of Richards and Ogden,[35] or to glance at the table of contents in Rader's *A Modern Book of Esthetics*. In the latter work we find no less than twelve differing theories, art or beauty being by different theorists primarily interpreted in terms of the following: Play (Lange and Groos), the Will to Power or Wish Fulfilment (Nietzsche, Freud, and Parker), Expression or Communication of

35. For these definitions, see the following: Ogden, Richards, and Wood, *The Foundations of Aesthetics* (London, 1922), *passim;* Ogden and Richards, *The Meaning of Meaning* (4th ed. New York, 1936), chap. vii; Richards, *Mencius on the Mind*, pp. 100–104. A succinct and useful list of theories of art is given by Louis Grudin, *A Primer of Aesthetics* (New York, 1930), p. 229.

Emotion (Véron, Tolstoy, and Hirn), Pleasure (Marshall and Santayana), Intuition and Technique (Croce, Bergson, and Bosanquet), Intellect (Maritain and Fernandez), Form (Parker, Bell, Fry, and Carpenter), Empathy (Lipps and Lee), Psychological Detachment (Bullough and Ortega y Gasset), Isolation and Equilibrium (Münsterberg, Puffer, Ogden, Richards, and Wood), Cultural Influence (Spengler and Mumford), and Instrumentality (Morris, Dewey, and Whitehead). Granted that there is no direct conflict between most of these doctrines, nevertheless this list, which reflects only recent opinions, gives a slightly dizzying picture of the variety and diversity of contemporary esthetics.

One will receive a similar impression, in this case from a highly restricted point of view, by contrasting typical concrete instances of attitudes which may be roughly labeled "objective" and "subjective."

(a) Beauty and art are frequently held to be some sort of quality or property of things. Prall, for example, says that beauty "is a quality of the object apprehended" and adds that "if it is properly only a tertiary quality so-called . . . it is still an objective quality just as truly as any other—shape or size or redness." [36] Objective too is Greene's contention that "*any* formal organization or pattern which is intrinsically satisfying may be said to possess beauty"; and, correspondingly, a "work of art," which is what Greene means by the word "art," is "an intrinsically satisfying and, at the same time, a *meaningful* organization of some appropriate medium." [37] Or again, Clive Bell tells us that the essence of works of art is pure or significant form.

(b) In contrast to such views are those which consider beauty and art to be primarily subjective. Thus for Mather,

36. D. W. Prall, *Aesthetic Judgment* (New York, 1929), p. 22.
37. T. M. Greene, *The Arts and the Art of Criticism* (Princeton, 1940), pp. 7, 11.

beauty is a "quality of a high human activity," [38] and for Venturi, "Outside artistic activity beauty does not exist, because nothing exists outside spiritual activity." [39] Also subjective in character, though stated with a more specific connotation, is Santayana's notion of beauty as "pleasure regarded as the quality of a thing." [40] Attitudes toward art, analogous to these, abound. Art is a "process or a transaction, a becoming," [41] "a quality that permeates an experience," [42] or simply "intuition." Some writers even hold that works of art are neither wholly objective nor "relatively objective," [43] but that they are rather "total activities," [44] since, "for art—and for aesthetics generally—objects do not exist, but only experiences." [45] This amazing use of language, which of course derives from an idealistic metaphysics, is thoroughly Crocean. In the Encyclopaedia Britannica, Croce speaks of "objects metaphorically called 'artistic objects' or 'works of art'" whereas "works of art exist only in the minds that create or recreate them." [46]

In brief, "art" and "beauty" are used either to designate referents which are qualities or relations of things, or referents which are mental activities. "Beauty" denotes now an objective or relatively objective property of an object, now a type of esthetic creation or response; and "art" refers sometimes to a physical work of art or to one of its qualities, some-

38. F. J. Mather, Jr., *Concerning Beauty* (Princeton, 1935), p. 2.

39. Lionello Venturi, *History of Art Criticism* (New York, 1936), p. 301.

40. George Santayana, *The Sense of Beauty* (New York, 1896), p. 49. Naturally, when beauty is defined in terms of value, one must know in what way the author uses "value." For Santayana, a value can exist only in perception.

41. Mather, *op. cit.*, p. 33.

42. John Dewey, *Art as Experience* (New York, 1934), p. 326.

43. This term is fully explained in n. 41 of the following essay.

44. R. G. Collingwood, *The Principles of Art* (Oxford, 1938), p. 151.

45. Lascelles Abercrombie, *An Essay Towards a Theory of Art* (London, 1922), p. 90.

46. 14th ed. I, 267.

times to the process of creation or appreciation, which in turn
is of course interpreted in a number of different ways.[47] Or
again, the two terms are used to stand for both types of ref-
erents (objective and subjective) simultaneously and am-
biguously. This verbal confusion, more common in everyday
conversation than in literature, may be disastrous to satisfac-
tory argument.

Now the variety of meanings in the foregoing quotations
should surprise no one who understands the semantic situa-
tion described in the first part of this book. That is, when
one realizes that similar language does not necessarily reflect
similar conceptions or similar referents, diverse uses of "art"
and "beauty" should be expected. Were this expectation
more constantly present, many of the disagreements in writ-
ings upon beauty and art would be readily and rightly ac-
counted for by the fact that different authors, while using
the same word, are in fact speaking of different things. This
phenomenon is the reverse of Schoen's suggestion, mentioned
earlier, that different esthetic terminologies refer to similar
things. And if semanticists are right, rather than Schoen, why
should there be a single subject of study called "esthetics"?
Why not several related studies to be severally investigated?
If this view were accepted, the endless and futile debates
about the "right" relation of art and beauty to esthetics might
cease and everyone might agree to smile at peremptory state-
ments like the following: "Thus Aesthetics, since [the time
of] Baumgarten believed to be the philosophical science of

47. Professor George Boas neatly summarizes various ways in which art is
considered subjective: "From the artist's point of view the proper end of
artistry has been said to be (a) self-expression, (b) the expression of an emo-
tion, (c) the expression of an idea, (d) the expression of an impression. From
the observer's point of view there are four corresponding theories, according
to which the end is (a) the revelation of a self, (b) the stimulation of an
emotion, (c) the communication of an idea, (d) the transfer of impressions"
(*A Primer for Critics* [Baltimore, 1937], p. 88).

both beauty and art, has but one object—ART." [48] Indeed, unless many new words should be coined to symbolize the numerous attitudes toward beauty and art, variety and contrast in esthetic theory must continue. But prevalent confusions can be avoided by recognizing the inevitability of divergent definitions and statements, by interpreting these correctly, and by defining one's own position with care.

(B) Volitional Definitions and Propositions

Less obvious than the linguistic diversity in esthetics and art criticism is the nature of the diverse linguistic forms. Are the esthetic approaches which we have loosely called attitudes, opinions, and interpretations, *in fact* volitional definitions, propositions, or real definitions? And what function can each of these three linguistic forms have in the solution of verbal and real problems of art criticism and esthetics? These are crucial questions.

Postponing, for the present, the confused and confusing real definitions, which will be the chief object of my attack, I should say that far too few initial pronouncements upon the nature of art and beauty are volitional definitions. To be sure, the authors of *The Foundations of Aesthetics* label as definitions the sixteen doctrines discussed; but these doctrines are for the most part explanations of referents rather than volitional definitions of terms; they seem to be, therefore, either real definitions or propositions. Often, unfortunately, the classification remains doubtful because the ambiguous auxiliary "is" in sentences beginning "art or beauty is" gives one pause as to the intended meaning. Writers are all too reluctant to use more awkward but far clearer verbal forms like: "It is in this sense that I use the words," or, "By art and beauty I mean such and such." Were such forms more regu-

48. F. M. Gatz, "The Place of Beauty and Art in Aesthetics," *The Journal of Aesthetics and Art Criticism*, Winter, 1941–42, p. 54.

larly employed, confusions would be immeasurably reduced
—*provided*, of course, the authors do not use the qualifying
phrases in a merely mechanical way, but specifically intend
by means of them to introduce volitional definitions. Unu-
sual, then, are the following: "Thus 'art' in the general sense
which I require is any selection by which the concrete facts
are so arranged as to elicit attention to particular values
which are realisable by them";[49] "I arbitrarily define beauty
as that which produces or tends to produce in the beholder,
under favorable conditions of mood and attention, an aes-
thetic response"; [50] and, "A complete unity of form and con-
tent, which is the only definition of beauty I understand, is
essentially a quality of the aesthetic experience" [51]—a re-
mark which combines, curiously, linguistic clarity with a wist-
ful ignorance of multiple definitions. Even when, however,
"art" and "beauty" are defined merely by the copula "is," no
serious confusion need result provided the author consistently
bases his ensuing explanations, descriptions, and so forth
upon his originally assumed definitions. But in all cases,

If we wish to indicate what we are referring to when we use the
word "Beauty" we should proceed by picking out certain starting-
points, such as nature, pleasure, emotion, or truth, and then
saying that what we refer to by "Beauty" is anything lying in a
certain relation (*imitating* nature, *causing* pleasure or emotion,
revealing truth) to these points.[52]

In contrast to volitional definitions are propositions like
the following, which are evidently about referents, not sym-
bols: "Art is for art's sake," "Art is an escape from chaos,"

49. A. N. Whitehead, *Science and the Modern World* (New York, 1941),
p. 287.
50. Elisabeth Schneider, *Aesthetic Motive* (New York, 1939), p. 29.
51. Andreus Ushenko, "The Relativity of Form in Art," *The Journal of
Aesthetics and Art Criticism*, Spring, 1941, p. 80.
52. Ogden and Richards, *The Meaning of Meaning*, p. 114.

and "The arts are our storehouse of recorded values." In such cases no *verbal* difficulties present themselves *provided* the meanings of the key terms are known.

The linguistic situation becomes more complex, however, when writers are making transitions from definitions to propositions, statements, or judgments. Each writer, that is to say, will wish not only to define his terms and to elucidate the definitions; he will naturally favor his own definition and will therefore attempt to show why, in his judgment, it is a thoroughly satisfactory one. For example, I hold that the definition of "beauty" as a simple quality, unanalyzable ultimate, or real universal is untenable; therefore I reject it completely. Or again, I believe that each opinion in the lists of Richards and of Rader is inadequate as a complete account of much esthetic experience; for while each one has some merit, each seems unduly restricted in scope. Positively I claim that the best definitions of "art" and "beauty" distinguish and separate their referents from all "ulterior ends" such as utilitarian or moral considerations which may be better discussed under the heading of some such terminology as "derived esthetic values." But such propositions as I have just been making are, to a degree, philosophical and ethical; like all propositions, they derive in the end from basic convictions, any discussion of which is unnecessary in the present context. In general, however, I would urge that, since symbolization in the field of esthetics and art criticism is exceptionally unfixed and unstable, no one volitional definition of "art" or "beauty" can justifiably be considered *the* most desirable one; and hence judgments about the volitional definitions of our key terms should be as undogmatic and as liberal as possible in their recognition of the claims of other judgments. For reasons already given, however, such a tolerant attitude should not be extended toward real definitions.

(C) *Real Definitions*

Problems raised by real definitions (definitions, it will be recalled, which attempt to reveal the Essence or true nature of the referent) may be first illustrated by the linguistic attitude of R. G. Collingwood. The first sentence of *The Principles of Art* states: "The business of this book is to answer the question: What is art?" Now as Rupert Brooke remarked: " 'One of the perils attending on those who ask, "What is art?" is that they tend to find what they are looking for: a common quality in Art. . . . People who start in this way are apt to be a most intolerable nuisance both to critics and to artists.' " [53] Collingwood's beginning, therefore, might well persuade anyone who is aware that this artificial question has no single true or correct answer to turn elsewhere for his reading unless semantic curiosity has been aroused. If it has been, the succeeding sentences will stimulate it further: "A question of this kind has to be answered in two stages. First, we must make sure that the key word (in this case 'art') is a word which we know how to apply where it *ought* to be applied and refuse where it *ought* to be refused" (my italics). And on the following page, the further stage of the answer is given: "Secondly, we must proceed to a definition of the term 'art.' This comes second, and not first, because no one can even try to define a term until he has settled in his own mind a definite usage of it." This whole procedure, seemingly so plausible and stated so clearly, succinctly, and dogmatically, is fallacious.[54] It admirably illustrates the misguided position of

53. Quoted by Michael Roberts, *Critique of Poetry* (London, 1934), p. 64.

54. In one sense, of course, definitions do come second rather than first. It would obviously be absurd, that is to say, hastily and arbitrarily to concoct definitions without first examining the referents or qualities of experience which the words are intended to designate. Burke was therefore justified in saying: "But let the virtue of a definition be what it will, in the order of things, it seems rather to follow than to precede our inquiry, of which it ought to be considered as the result" ("A Philosophical Inquiry into the

those who, while conscious of the need for some sort of definitions, nonetheless hold that they are secondary considerations which are regulated and prescribed by usage and which, therefore, are either true or false. Such definitions are not volitional ones which give words their meanings, nor are they dictionary ones; rather, they are real ones used to explain meanings which "ought" already to exist. Thus Collingwood proposes both to have his cake and eat it: to discover from usage the Essence, meaning, and significance of art, then to define it according to that usage which seems to him correct. He wishes, in other words, both to make a proposition about and a definition of art, to reveal something important concerning its Essence and to define art correctly in terms of this something. It apparently never occurs to him that significant propositions can be made only *after* the meanings of the terms are already known and that, therefore, definitions logically precede propositions.[55] The procedure of

Origin of our ideas of the Sublime and Beautiful," *The Works of Burke* [The World's Classics], p. 67). Collingwood's meaning, however, is a different one—as the following sentences in the text attempt to prove.

55. The view I am attacking is entrenched in the minds of many philosophers. Thus in reading a draft of this essay Professor Wheelwright commented at this point: "I dare say it has occurred to him and been rejected. Such, at least, is the case with me. Your stipulational [i.e., referential] method of definition is useful in certain fields (monosignative ones) but not, or anyhow not exclusively, in art criticism." Although in the preceding section of this essay the need for distinguishing between propositions and volitional definitions was stressed, the point needs further reinforcement. I cannot do better in replying to Wheelwright than to quote an important passage of I. A. Richards: "There is nothing, alack! unusual about such a manoeuvre in argument" (i.e., the use of language simultaneously as a proposition and as a definition). "Logically it is fatal; rhetorically it is often triumphant. It is encouraged by the usage doctrine. For if we feel usage is looking after and regulating the 'significations' of words, we are inclined to feel less distinctly that we are giving a word its meaning (arranging by the setting how it shall be understood) and are more apt to assume that it comes to us with a normal and already settled meaning. Then, however arbitrary we may actually be, we tend to feel that usage backs up the meaning. Similarly the usage-indoctrinated reader tends to take it as backed up so, without looking to see just which of the countless usages is doing the backing. And *there* is the

writers, like Collingwood, who do not accept this logic, calls to mind a quip from Chaplin's "The Gold Rush": "Before I know where I am, I must get there."

Collingwood's liking for real definitions appears again in the answer he gives to his initial question: What is art? "Art," we are told, "is the imaginative expression of emotion." [56] Now this conclusion presents neither a proposition about art in which the key words have been previously defined, nor a definition which arbitrarily gives to "art" a meaning. Rather, it attempts simultaneously to do both: to say something significant about art and to say it in terms of a real definition which, magically, is supposed to give the essential or true meaning of art. Thus Collingwood harps continually upon the distinction between art "proper" and "improper." Thoroughly conscious though he seems to be that the words "art" and "beauty" have and have had a variety of meanings in the course of their history, he is nevertheless compelled to reject as improper all of those meanings which do not reveal what is for him the essential nature of the referents. For example, "The entire body of medieval Christian art" is magical in purpose and hence not art proper; and, "Aristotle's *Poetics* is concerned not with art proper but with representative art." [57] Or again, having categorically defined a work of art as a "total activity which the person enjoying it apprehends, or is conscious of, by the use of his imagination," [58] Collingwood is logically compelled (according to his misconception of definition) to reject as false all considerations

trap with these quasi-definitions. If usage does back it up thoroughly the thing turns into an empty tautology: 'a collection etc. is a collection etc.' But if usage does not back it up enough, then it is very doubtfully true. The peculiar half-way-between, looking both-ways, position gives it both its seeming truth and its seeming content, its plausibility and its air of saying something" (*Interpretation in Teaching*, p. 256).

56. Collingwood, *op. cit.*, p. 252.
57. *Ibid.*, p. 114.
58. *Ibid.*, p. 151.

of works of art as objective structures. What has happened in this case, one queries, to the appeal to usage?

In his brief discussion of the words "beauty" and "beautiful," Collingwood is at pains to insist that these terms, "as actually used, have no aesthetic implication." [59] Therefore he attacks the views of those who connect beauty in any way with art[60] and claims that whenever the term "beauty" is properly used, it simply characterizes something as excellent or admirable. This dogmatic conviction is determined partly by historical precedent (a matter which conveniently carried no weight in his discussion of art), partly by popular current usage. The important point for us as well as for Collingwood, however, is that *his* usage alone is considered correct and all other uses of the words are wrong. It is amusing, therefore, to be able to indict this philosopher in his own words by characterizing his entire verbal approach as

one of those all too frequent attempts on the part of philosophers to justify their own misuse of a word by ordering others to misuse it in the same way. We ought not, they say, to call a grilled steak beautiful. But why not? Because they want us to let them monopolize the word for their own purposes. Well, it does not matter to anybody but themselves, because nobody will obey them. But it matters to themselves, because the purpose for which they want it . . . is to talk nonsense.[61]

Similar linguistic difficulties abound in the writings of Croce. Indeed one may plausibly argue both that the appeal of his esthetic system depends to some extent upon the fluency and vagueness of his language and that the rejection of this system is caused to a considerable degree by his verbal errors. Adherents of Croce, that is to say, will always be those who

59. *Ibid.*, p. 38.
60. Cf. T. M. Greene in *Journal of Philosophy*, July, 1938, p. 367: "A work of art is by definition beautiful."
61. Collingwood, *op. cit.*, p. 40.

not only are susceptible to an idealistic metaphysic but who also are easily persuaded by language that is, in the main, loose, unspecific, and abstract; and conversely, his opponents will object not merely to his philosophic idealism but even more, if they are at all semantically minded, to the verbalistic manner in which it is expounded. Thus, while the esthetic writings of Croce raise real problems of great interest, these problems can only be intelligently discussed when Crocean verbal snares have been resolved. For example, Professor Bowers remarks in regard to the Crocean question: can we always express what we intuit?

This question is ambiguous: (1) If it means Can we always express *for ourselves* what we really intuit? the answer is yes, for we can always devise a symbolism whose meaning is clear to us. But Croce cannot mean the assertion in this form since it implies that there can be no *degree* of expressiveness. (2) If it means: can we always *communicate* to others what we really intuit? (which appears to be Croce's meaning) the answer is *no;* for communication presupposes a common language and a capacity to use it; and to have intuitions does not entail capacity to manipulate a common language.[62]

Croce's identification of intuition with expression and of both with art is the central feature, as everyone knows, of his esthetics. Now in the first place, nothing important is or could be accomplished by the substitution of these words one for another as strict synonyms, and in the second place, precisely what does Croce mean by any of these key terms? Does he define them? And if so, what sort of definitions does he give? In his discussion of intuition, Croce tells us that intuitive knowledge is one of the two possible types of knowledge, and that it is obtained through the imagination; he tells us further that intuition is not a sensation and that percep-

62. D. F. Bowers, in an unpublished lecture.

tion, concepts, space, and time are all unnecessary to intuition; finally, he identifies intuition with expression. This unusual interpretation of intuition leads one to ask: is Croce giving a volitional definition of the word "intuition" which everyone should temporarily accept and which will be a useful tool for his later argument, or is he attempting to say something important about intuition at the same time that he defines it? The answer is given by Croce himself when he announces his concern for "a true and precise idea of intuition" and for "the real nature of intuition." [63] Evidently we are not dealing with a volitional definition but with a real one, which purports to present the Being or Essence or Fundamental Nature of a referent. And so it is with the famous dictum "Art is intuition." In this case Croce is neither stating a proposition in which the terms have already been volitionally defined, nor is he giving a volitional definition which, along with several other possible definitions, may be more or less helpful in explaining various facts of esthetic and artistic experience; rather, he wishes to reveal the "true nature of art," to propound "art as art," i.e., to do what we have discovered to be impossible and meaningless. No wonder such confusing verbalizing has produced extensive comment.

This basic linguistic error is the more remarkable since Croce, like Collingwood, refers again and again to different uses of words, to various meanings and interpretations of terms; and when defining the sublime, he makes a remark with which no semanticist would take issue: "The sublime (comic, tragic, humoristic, etc.) is *everything* that is or will be so *called* by those who have employed or shall employ this *word*." [64] Why is it, then, that Croce does not adopt a similar attitude toward art and beauty? The chief reason, perhaps,

63. Benedetto Croce, *Aesthetic* (London, 1909), p. 5. Douglas Ainslie, trans.
64. *Ibid.*, p. 147.

is because he is strongly inclined toward that organic view of meaning which directly prompts the use of real definitions.

Consider as further examples of Croce's linguistic methods, two comments in his *Aesthetic* upon beauty. In one place, he says: "We may define beauty as *successful expression*" [65]—seemingly a permissible point of view since the comment is *apparently* intended as a volitional definition; yet thirty pages farther on, we learn that to call *things beautiful* is "a verbal paradox, because the beautiful is not a physical fact; it does not belong to things, but to the activity of man, to spiritual energy." [66] This latter quotation indicates, first that Croce's previous definition of beauty as "successful expression" is in fact—even though it is introduced by the propitious yet apparently mechanical words "we may define"—a real, not a volitional one, and second that, for whatever reason, he is unwilling to apply his sensible position concerning a definition of the sublime to a definition of beauty. Added proof of these facts is afforded by his astonishing words in the Encyclopaedia Britannica: "The old and only idea of what art is." [67]

One capital illustration from Crocean criticism will show further weaknesses which real definitions promote. Professor Lionello Venturi who, like Croce, gives a real definition of art in terms of intuition or creative imagination, lately remarked:

The intellectual satisfaction found in geometric shapes, which Plato called beauty, has no connection with creative imagination. Mr. [Herbert] Read, unaware of this misunderstanding, writes: "The result (of cubist art) is a work giving true pleasure, in no way depending on the representation of the object, not relative to its use or associations, but always and naturally and absolutely beautiful." A cubist painting [Venturi goes on to say] does not give pleasure, nor does it appear beautiful; but even

65. *Ibid.*, p. 129.
66. *Ibid.*, p. 159.
67. 14th ed., I, 269.

if it did, because pleasure and beauty do not make up a work of art, the explanation would be inconclusive.[68]

If we pass over the extraordinary assertion that "a cubist painting does not give pleasure, nor does it appear beautiful" —an assertion which flatly contradicts the experience of many discerning people—the most interesting point to notice is the undesirable result which ensues from Venturi's restricted and rigid real definition of art. Although for innumerable sensitive persons the communication of beauty and pleasure has been for centuries and continues to be the *sine qua non* of artistic creation, Croce and his clan believe they have conclusively demonstrated that it is unessential. Were their definitions of art and beauty volitional ones, we would readily tolerate, though we might not agree with, their position. But the situation is quite otherwise. Their statements abundantly prove that, instead of volitionally defining terms and *then* making propositions about the qualities of experience in question, they are attempting to say something significant about referents whose meanings they incorrectly presume to have been settled by usage. This procedure, we have urged more than once, is inadmissible.

Before illustrating real definitions at greater length, I should like, if possible, to meet the objection of those readers who are thinking: "But *I* seem to understand well enough what Collingwood, Croce, and Venturi are saying. Even if their meanings are not perfectly expressed, why this quibbling over terminology? I see nothing really pernicious in their verbal errors. Surely the attack of this author is disproportionate to the offense of his subjects." In answering this challenge, there seem to me to be three points worth making.

(1) The mistakes under consideration are harmful from a linguistic standpoint. Consider, for instance, the insistence of Collingwood, Croce, and Venturi that their "definitions" of art and beauty are true and that all others are false. To

68. *Art Criticism Now*, p. 27.

be sure, those who understand why such real definitions are linguistically treacherous—i.e., because they blur the all-important distinction between naming something and making a proposition about that something—will not be unduly persuaded or affected by them. Many readers, however, will not readily see the linguistic thicket. Rather, they will be amazed and bewildered at being dogmatically informed that certain "definitions" which, they observe, directly conflict with those of other critical experts, are the only true ones. The verbal predicament of such readers is directly caused by a misunderstanding of real definitions.

(2) The mistakes under consideration are also harmful to ontological problems. Real definitions, we have seen, attempt to state something "significant" or "true" about their referents; but semantics teaches one to question deeply this alleged significance or truth because it is expressed, as we have also seen, in highly ambiguous terminology. Once again, however, many readers, not readily seeing the linguistic thicket, will probably be won over—partly, no doubt, because of the persuasive and dogmatic tone of the language —to views which seem exceptionally convincing just because they are expressed in the form of real definitions.

(3) The mistakes under consideration are the chief cause, I am convinced, of *the* basic confusion in the teachings of esthetic theorists. In this respect, therefore, semantic errors are more than harmful; they are disastrous. Because the majority of estheticians, that is to say, incorrectly believe they can tell us what art or beauty *is* and attempt to do so, the essential claims of each writer are invalidated by the contradictory claims of another. Such a lamentable state of affairs, which could not occur of course with volitional definitions *no matter how contradictory* they might be, occurs principally because these writers, wittingly or unwittingly, formulate their beliefs in terms of real definitions. Hence, is it surprising that many sensitive people today argue that most writing

upon esthetics is sterile? Is it not natural that these people should regard this writing as being primarily of autobiographical interest?

The dangers in the use of real definitions and the frequency of that use in esthetics and art criticism may be further stressed by citing characteristic samples from the writings of Dr. Coomaraswamy: "Aesthetics, then, the science of sensation, rightly claimed by the psychologist as belonging to his field of experimental science rather than to philosophy, is not the science of beauty, but the science of preferences." [69] In this passage we are being told what esthetics *is:* not how the word "esthetics" has been used or is used or should preferably be used, but how, because of the intrinsic character of its supposedly unchanging referent, it must be used—if we would not err. Metaphorically hypnotized as Coomaraswamy seems to be by the potency of words and by their traditional meanings, he fails to understand that the term "esthetic" may legitimately mean something quite different from his and from traditional interpretations. He is therefore able to attack not only the definition of esthetics as the philosophy or science of beauty, but to consider the current association of esthetics with disinterested contemplation false. The notion indeed of disinterested esthetic contemplation is for Dr. Coomaraswamy a "contradiction in terms"—because, of course, only *his* meaning of "esthetic" is the real or true one.

The same dogmatism in regard to meaning, the same unwillingness to grasp the flexibility and the utilitarian character of language occurs in his discussions of art and beauty. "With Plato, and with Thomas Mann, we should refuse the name of art to anything irrational." [70] The point I am concerned to challenge in this quotation is the implication that "the name of art" possesses intrinsically a special significance which must not be contaminated. In this and other passages

69. A. K. Coomaraswamy, *The Art Bulletin*, June, 1939, p. 205.
70. From a lecture entitled, "Figures of Speech, or a Figure of Thought?"

Coomaraswamy creates the impression that there is something almost sacred about such terms as "esthetic," "beauty," "art," "decoration," and so forth. In this connection, therefore, it is amusing and instructive to mention a reference by J. C. Ransom to "the absolute name of art" which he would refuse to apply to precisely that "moralistic" traditional "rhetoric" which, according to Coomaraswamy, most deserves to be called art! [71] Thus do the intellectual dogmatists contradict one another upon linguistic matters which, if properly understood, should cause no trouble whatsoever; for while, as I insisted in the foregoing section, the correct semantic procedure by no means commits one to the irresponsible way of Humpty-Dumpty, to talk about the "absolute name" of anything at all seems downright nonsensical.

Elsewhere Coomaraswamy claims that "we misuse language when we speak of objects as 'art,' " [72] a point of view shared, as we have observed, by Collingwood and Croce. But why are we thus misusing language? The likely reply of Coomaraswamy that the etymology of the word is opposed to the sense he is attacking should persuade no one who has observed the vicissitudes of meaning which all such terms have undergone and who is not unduly impressed, like Socrates in the *Cratylus,* by the supposed magic of words or by the supposed significance of their traditional meanings. Or if Collingwood should argue against calling objects "art" from the platform of usage, he could easily be refuted by sheer fact; for today the majority of writers and teachers use the term "art" to refer to certain kinds of objects, and no one can prevent them from doing so. Of course it is unfortunate that the term often refers ambiguously both to objects and to creative activity, but if the verbal confusion is to be remedied in the near

71. For Ransom's view, see "Ubiquitous Moralists," *The Kenyon Review,* Winter, 1941. Coomaraswamy's defense of "moralistic" traditional "rhetoric" is explained on pp. 133–134.

72. Coomaraswamy, *The Art Bulletin,* June, 1939, p. 205.

future by consistently employing separate terms for the two kinds of referents, the easier and more practical solution would probably be not to restrict "art" to the creative process, but rather to restrict it to the objective works and to characterize the subjective aspect, following Professor Boas, as "artistry."

One other example of a philosopher's use of the word "beauty" will interestingly show how readily one may slip from a volitional to a real definition. In *The Meaning of Beauty*, Mr. Stace begins, happily, by distinguishing between different senses of the term "beauty," and the first paragraph concludes with the statement that "it is in this sense," i.e., as "aesthetic experience generally," "that I shall use the words beauty and beautiful in this book." [73] In the ensuing paragraph, however, Stace changes his tune and begins the fatal search—the search for *the* meaning of beauty. He affirms, with most philosophers from Plato on, that there must be "a common nature" to the great variety of esthetic objects, and he therefore asks: "What is this common nature?" [74] Now

73. W. T. Stace, *The Meaning of Beauty* (London, 1929), p. 10.
74. In the essay upon Value Judgments I shall argue against this procedure, but since Professor Wheelwright comments as follows upon the preceding sentence: "This seems to me self-evident; although the common nature may be evanescent and not explicitly discoverable," I shall once again answer him by a quotation from Dr. Richards: "Four stages of relative naïvety or sophistication may be remarked in our handling of this word *beauty*. The least sophisticated view assumes that, of course, things are beautiful or not *in themselves,* just as they are blue or not blue, square or not square. A less naïve view plunges to the other extreme and regards beauty as 'altogether subjective,' as perhaps merely equivalent to 'pleasing to the higher senses.' A still more sophisticated view reconstructs again—as a counterblast to this 'subjective view'—a doctrine of real inherent objective tertiary qualities, giving it a complex philosophical and logical scaffolding and perhaps venturing some provisional formula as a description of this property—'unity in variety,' 'logical necessity in structure,' 'proportions easeful to the apprehension,' and so forth. Lastly a perhaps still more sophisticated view reduces this formula to something so vague and general that it ceases to be useful as an instrument for investigating differences between what is said to be beautiful and what is not. For example, if we define *beautiful,* as I suggest for this

most answers to this question produce real definitions. Mr. Stace gives the following:

The theory which I propose may be summarized in the **PROPO-SITION** that *beauty is the fusion of an intellectual content, consisting of empirical non-perceptual concepts, with a perceptual field, in such manner that the intellectual content and the perceptual field are indistinguishable from one another; and in such manner as to constitute the revelation of an aspect of reality.* We must, firstly, explain the meaning of this **DEFINITION** [my capitals].[75]

How ideally this passage from the chapter "The Essence of Beauty" exemplifies the criteria of a real definition is evident even from the two words used to characterize the italicized portion: Stace begins by calling his real definition a "proposition," but concludes by calling it a "definition"! Could the explanation of a real definition as a confused hybrid between a proposition and a volitional definition be more neatly illustrated?

One specific and characteristic snag confronts Stace when he considers the question of color in relation to his definition of beauty. Having decided, irrevocably, that a *sine qua non* of beauty is an "intellectual content, consisting of empirical non-perceptual concepts," yet being aware that color has little or no connection with "intellectual content," Stace is compelled—clearly to his regret—to conclude that "we have in colour-schemes only pleasant physical sensations, not

purpose we might, as 'having properties such that it arouses, under suitable conditions, tendencies to self-completion in the mind' (or something more elaborate of this kind), *beauty* ceases to be the name of any *ascertainable* property in things. It is still objective, it is still the property in virtue of which the beautiful thing does arouse these tendencies. But we cannot take these beautiful things and look to see what they have in common, for in fact they need have nothing *in common* (if the conditions are dissimilar) beyond this purely abstract property of 'being such as to arouse, etc.'" (*Practical Criticism* [London, 1929], p. 359).

75. Stace, *op. cit.*, p. 43.

beauty." [76] Such a difficulty as this can only be important and exasperating to those who, like Collingwood, Croce, Venturi, Coomaraswamy, and Stace, are determined to seek and to find the "true nature," "Essence," or "Reality" of mythological referents or "ghosts."

Since part of my purpose in discussing real definitions has been to show the seriousness of the confusions which they produce, a number of examples have been chosen from the works of a few influential scholars. But since my purpose also is to suggest the extensiveness in the use of these definitions and since I wish to avoid giving the impression that I am merely attacking the writings of a few specific individuals, I shall now add four examples of what I take to be real definitions, each by a different author. All of these and many more may be found in the selections from Rader's *A Modern Book of Esthetics*. Having considered real definitions at some length, we need not analyze these final samples; yet I would call attention particularly to the striking and basic contradiction—a by no means uncommon phenomenon in esthetic theory—between the two pronouncements upon art, *both* of which, one should observe, contradict in an equally striking and basic manner the real definition of Venturi previously cited. (i) "Art is the partly innate and partly acquired capacity of man to give to himself and others a pleasure based upon illusion and free from any conscious aim except the immediate enjoyment" (Lange). (ii) "In order *correctly* to define art, it is necessary, first of all, to cease to consider it as a means to pleasure, and to consider it as one of the conditions of human life. Viewing it in this way, we cannot fail to observe that art is one of the means of intercourse between man and man" (Tolstoy) (my italics). (iii) "The beautiful is what gives joy, not all joy, but joy in knowledge; not the joy pecu-

76. *Ibid.*, p. 121.

liar to the act of knowing, but a joy superabounding and overflowing from such an act because of the object known" (Maritain). (iv) "This complete repose, where the objective impression becomes for us an ultimate end in itself, is the *only possible* content of the *true* experience of beauty" (Münsterberg) (my italics).

(D) *Exaggerated Uses*

The italicized words in the quotations of Tolstoy and Münsterberg are excellent examples of a tendency to which I shall now very briefly call attention: a tendency toward verbal exaggerations. To illustrate these further, I select sentences from two writers, T. M. Greene and F. J. Mather, Jr., whose works I particularly admire. In what follows it will be seen that the exaggerations primarily affect genuine propositions or statements which are based upon ontological convictions and which, therefore, entail judgments of true and false. To *argue* at this point the truth value of the propositions would not be pertinent; yet one may observe (i) that the obvious contradictions between the two writers make it apparent that, according to an absolute theory of value, the esthetic approach of at least one of them must be false, and (ii) that while, according to the relativist position defended in the following essay, neither approach is wholly wrong, both are largely invalidated by verbal exaggerations.

Professor Greene says, "The *ultimate* fact in *all* aesthetic theory is the completed work of art in all its concreteness and organic unity";[77] and again, "The object is *correctly* designated as "beautiful" if its formal structure occasions genuine esthetic delight." [78] Now the words which I have italicized

77. *The Arts and the Art of Criticism,* p. 126.
78. Greene, "Beauty and the Cognitive Significance of Art," *The Journal of Philosophy,* July, 1938, p. 366.

give to each sentence an overemphasis which is misleading. Just why is Greene justified in stating that the completed work of art is "the ultimate fact" in "all" esthetic theory when certain theories make different claims? To be reasonable, Greene should either say "an important fact in all esthetic theory" (and even the truth of this proposition is highly questionable), or "the ultimate fact in my esthetic theory." In the second sentence quoted, the simple expedient of adding after "beautiful," "according to my definition of beautiful," or of substituting "may be" for "is correctly" would remove a serious verbal ambiguity; for as the sentence stands, one cannot be certain whether Greene's implicit meaning is equivalent to what it would be explicitly if such qualifying phrases were added, or whether he is saying that "beautiful" has only one correct meaning—a judgment which we have seen to be false.

The unwisdom of these mistakes is the more evident when we compare them with similar ones of Dr. Mather which present, it is important to notice, quite opposite views. For Mather, a work of art is "something that produces effects, and *only* in these effects can it profitably be studied";[79] and, "Art is a process or a transaction, a becoming—a state of mind in the artist becomes a picture; the picture in turn becomes a similar state of mind in the spectator. These states of mind are our *proper* study. Esthetics is *merely* a special branch of psychology"[80] (my italics). Is it not evident that the words "only," "proper," and "merely" render the propositions (or are they real definitions?) highly questionable? And do not the exaggerated statements of each of these writers accentuate the errors in the opposed views? If this is so, verbal exaggeration undoubtedly accounts for some of the confusion in art criticism and esthetics.

79. *Concerning Beauty*, p. 3.
80. *Ibid.*, p. 33.

(E) Laudatory Uses

In this discussion of the words "art" and "beauty," I have said nothing about the most familiar of all uses of "beauty." Again and again in our daily conversation we use "beauty" or "beautiful" in a laudatory way: we wish to remark that something is fine, delightful, excellent, admirable, and the like. In so doing, we express or arouse emotions by our language, but do not refer to any *specific* quality or state of affairs. The connotation, not the denotation of the word, is of first importance. To be sure, when calling attention to a "beautiful character" or to "beautiful weather," we are partly referring to some referent; yet the features of this laudatory language which preëminently distinguish it are: (i) the importance of the "Gesture," to use Richards' terminology, rather than the "Sense" of the "total meaning" (i.e., the importance of the "intention," "feeling," and "tone" expressed or evoked); and (ii) the indefiniteness with which the words indicate the quality or state of affairs being referred to. Such language, in brief, is more "emotive" than "referential," vague rather than precise.[81]

Although laudatory meanings of "beauty" are most common in speech, they also occur in all sorts of writings upon art. Indeed it would be difficult to find a book on art which did not contain uses of "beauty" that are primarily emotive, and that refer only loosely to an objective state of affairs. In skimming a few pages of books selected more or less at random, I find these typical remarks: "Imagine, he [Picasso] said, if Michael Angelo would have been pleased if some one had given him a fine piece of Renaissance furniture, not at all. He would have been pleased if he had been given a beautiful Greek intaglio, of course." [82] "He [Raphael] has interpreted the noblest aspirations of man, with a clarity, beauty, and

81. One should recall in this context the exceptional flexibility in meaning, mentioned on pp. 8–9, of "adjectival" words.
82. Gertrude Stein, *Picasso* (London, 1939), p. 31.

power that remain unrivalled";[83] "The group around the beautiful dead animal . . . strikes us as pathetic rather than funny";[84] "The landscape is developed in broad pastoral passages of supreme beauty";[85] "Dainty female hands are as beautiful as flowers or gems set in stellar design. In the panel of the *Calunnia* in the Uffizi Gallery you see a beautiful group of three maidens." [86]

In these examples, and in countless others like them, it is clear that a major function of the words "beauty" and "beautiful" is to express what the writers *like*. One might fairly substitute for "beautiful" such adjectives as "splendid," "distinguished," "lovely," "exquisite," and so forth. Such synonyms do not of course render the meanings more specific; they merely strengthen the argument that this sort of language is decidedly emotive.

But is not this language more than emotive? In addition to expressing subjective praise, do not the writers in some way wish to indicate that what they are speaking of is artistically successful or significant? Instead of merely expressing "what pleases me," are they not also pointing to referents that should please every judicious observer? If we answer these questions in the affirmative, as I think we should, one may then inquire: what is the nature of the objective referents? and to what extent do the writers intend to stress them? In an experimental attempt to answer these questions, a number of art historians interpreted the words "beauty" and "beautiful" in the quotations cited above. The results of this experiment in interpretation were so extraordinarily diverse that only one unanimous conclusion was arrived at: namely, that no satisfactory answers to the questions are ascertainable. In brief, although most laudatory uses of "beauty" seem to show some concern

83. Sir Charles Holmes, *Raphael* (London, 1933), p. 133.
84. Erwin Panofsky, *Studies in Iconology* (New York, 1939), p. 222.
85. Edith Abbot, *The Great Painters* (New York, 1927), pp. 166–167.
86. Yukio Yashiro, *Sandro Botticelli* (revised ed. Boston, 1929), p. 114.

for objective referents, one cannot with any precision determine either the kind of referents intended or the relative importance of these referents in the total meaning.[87]

What judgment shall we pass upon such uses of "beauty" as the foregoing? In contrast to the problems raised by real definitions and by verbal exaggerations, we are not dealing with linguistic forms which are wholly confused or misleading; rather, we are dealing with a type of language which might be described either as "treacherous" or "resourceful." Those who prefer critical writing that always states meanings clearly and precisely will resent a style which uses terms in a loose fashion; but others, who prefer critical writing that is "impressionistic," "evocative," "rich," or "full" in connotations, will praise a style which uses terms in a way that, for them, is not so much vague and ambiguous, as suggestive and stimulating. Thus the amount of laudatory discourse which is desirable in writings about art is probably a matter of choice or taste. One should not be dogmatic about it.

Even those who desire clarity and precision of meaning in critical writing, however, will recognize the convenience or

87. If correct, this conclusion would necessitate a qualification in Mr. T. C. Pollock's "pragmatic-referential" linguistic category. In *The Nature of Literature* (Princeton, 1942), p. 169, he says: *"Pragmatic-referential* is so named because in it the writer's purpose is *both* to point the attention of a reader toward certain referents *and* to stimulate him to assume a certain attitude toward them or to act in relation to them in a specific way." While Pollock's entire new classification of uses of language is interesting and valuable, I do not believe that it invalidates, as it attempts to do, Richards' classification. *All* these divisions between "emotive and referential," "evocative and symbolic," "feeling and thought," and so on, seem to me helpful in semantic analyses; but, as Richards says, they "easily mislead us if we forget that they are abstractions, theoretical machinery made for special purposes, not actual cleavages in the stream of the mind's activity. They are useful, indispensable for their special purposes—literary criticism, the description of linguistic devices, the analysis and contrasting of different types of utterance: the scientific treatise, the sermon, the political speech. . . . But they do not hold outside their purposes, they do not apply directly to the make-up of the mind, only to some of the phases of its activity" (*How To Read a Page*, p. 100).

even the desirability of certain laudatory uses of "beauty." If a critic who is primarily concerned with historical problems, nonetheless wishes in passing to call attention to the excellence of a particular painting or to a portion of it, the adjective "beautiful" will admirably serve his purpose. He could, if required to, specify exactly what he means by the term; but it would be irrelevant to do so. The sentence of Panofsky quoted above illustrates this usage. In contrast, other laudatory uses of "beauty" are so extraordinarily hazy that one cannot reasonably claim either convenience or desirability for them. A single example from the work of a distinguished art historian may be cited: "Beauty and harmony characterize all the works executed by Murillo in his maturity. A prevailing feature of the beauty cherished by him is a sweetness which may easily give way to the sugary." [88] Even though in the second part of this quotation Weisbach names the quality "sweetness" as an attribute of Murillo's beauty, the meaning of "beauty" remains hopelessly vague and ambiguous. While such vagueness and ambiguity (which occur also, I suggest, in the Yashiro quotation cited) are not, perhaps, downright misleading, they are, to a greater or lesser degree depending on the specific context, bewildering and confusing. They should therefore be eliminated from criticism. Indeed, if we do not condemn the ineffectual and needlessly obscure laudatory language of eminent authors, how may we hope to persuade students that their similar linguistic forms are inadmissible?

In summing up this discussion of "art" and "beauty," I would first stress the resourcefulness of these words. We have on several occasions noted the diversity of interpretations which writers have given and continue to give them, and we have insisted that elasticity in their meanings is not only permissible but desirable. The semanticist, that is to say, does not oppose variety in the uses of "art" and "beauty"; he welcomes

88. Werner Weisbach, *Spanish Baroque Art* (Cambridge, England, 1941), p. 62.

it. He will accept many different volitional definitions of these terms, and he will approve, *from a semantic standpoint,* all propositions in which the meanings of the terms are explicitly or implicitly given.

While accepting such linguistic flexibility, however, the semanticist is keenly aware that some uses of language are confusing and misleading. I have illustrated and challenged these uses in an attempt to achieve the aim stated in the opening sentence of this book: i.e., to show in what *ways* and to what *degree* linguistic confusion is responsible for the inadequacy of contemporary art criticism and esthetics. Our analysis has considered three main causes of semantic confusion: real definitions, verbal exaggerations, and verbal vagueness; and the analysis has shown that, of these three abuses, real definitions are distinctly the most serious.

If we now, finally, try to state the degree of confusion in art criticism and esthetics caused by the several misuses of the words "art" and "beauty," we must, in formulating a solution to this problem, once more avoid dogmatism; for it is evident that the degree of confusion will vary considerably according to the type of reader and that, therefore, one cannot possibly assert in exact terms just what this degree is. Nonetheless, I am convinced that the confusions thus far discussed are deeply rooted and widespread, and that they are a major reason for the unsatisfactory state of current writings upon art. In the following pages I shall attempt to demonstrate further this conviction by other sorts of semantic analyses, then pass on to our second major critical problem: namely, value judgments.

III. "ARTISTIC TRUTH"

PHILOSOPHERS and critics have been much exercised over the problem of truth as a criterion for art; and competent opinions on the subject diverge all the way from those which claim that truth is a wholly irrelevant consideration to those which claim it as a basic critical postulate.

The problem of artistic truth is peculiarly perplexing because of verbal intricacies which require unraveling. To be sure, there are "real" questions about artistic truth: for example, the question of the relevance of the artist's "beliefs," as they are expressed in a work of art, to the critic's appraisal of that work. Granted the importance of such real problems, I nonetheless believe that much of the disagreement upon the subject of truth in art results from semantic befuddlement; and I believe that satisfactory interpretations of a number of uses of the word "truth" will go far toward solving our present problem. In what follows I shall try to explain and to differentiate various modes of truth, and to indicate the degree of efficacy and applicability which these modes have when they are applied as criteria requiring truth in art.[89]

89. Of course no attempt is made to exhaust the modes of truth. Only those which one commonly associates with art are considered. Thus the idea of truth as Reality or an explanation of the universe is not taken up here. Moreover, those real definitions which unwisely try to answer the unanswerable question: what *is* truth? do not concern us since they belong rather to the subject of "semantics and philosophy," than to that of "semantics and esthetics" or to "semantics and art criticism." For further senses of the word "truth," the reader is referred to pp. 111–117 of Richards' *Mencius on the Mind.*

The following kind of analysis, as James Burnham pointed out to me, is possible only after various distinctions in modes of discourse have been historically established. Pre-Renaissance people could not have thought in these distinctions, and from their point of view, some of the problems presently to be considered (e.g., the notion of scientific truth) did not arise at all.

(A) "Truth" as an Undefined Term

Bearing in mind the significance of volitional definitions, we should readily agree upon the desirability of defining "truth" volitionally—either explicitly or implicitly—whenever we use the term in esthetic or critical writings. Unfortunately, however, certain philosophers and critics from all periods assume the existence of a referent, Truth, and proceed to refer loosely and vaguely to this elusive referent as "truth," "a kind of truth," "genuine truth," or "real truth," without attempting to clarify the issue by means of volitional definitions. Always, I feel, the resultant unclear meanings follow in part from that unreasonable emotional attitude toward words which attributes magic to them by regarding them as something more than linguistic tools.

The following example will well illustrate the effect which an unwillingness or inability to use volitional definitions may have upon the most fundamental problems of esthetics and criticism. In *The Meaning of Beauty*, Stace reaches the conclusions that esthetic judgments are universally valid and that "by the validity of aesthetic judgments is meant their truth for all men." [90] Presumably, then, one will want to know exactly what Stace means by the important phrase "truth for all men"; yet this crucial phrase is conveniently left unexplained: "*Why* truth is universally valid may be a matter of dispute, and depends upon the view taken as [to] the nature of truth, a problem which lies wholly outside aesthetics and the scope of our inquiry." [91] Thus, despite the author's own stated recognition of the dependence of the reason for the universal validity of truth upon "the view taken as the nature of truth," no attempt is made *in this context* to explain any view. In fine, the sense of his significant statement regarding the valid-

90. *The Meaning of Beauty*, p. 206.
91. *Ibid.*, p. 209.

ity of esthetic judgments becomes ambiguous through failure to define "truth" volitionally.

Usually, it seems, undefined uses of "truth" are emotive rather than referential, and indefinite rather than precise. As in the case of laudatory uses of "beauty," that is, the writers are primarily expressing and evoking feelings (which are often of the most hazy sort) , and are referring only in a vague, and frequently in a hopelessly vague manner to any quality or state of affairs. As a sample of these uses, consider this statement of the sculptress Malvina Hoffman: "Sculpture is a parable in three dimensions, a symbol of a spiritual experience, and a means of conveying truth by concentrating its essence into visible form." [92] In this sentence no clue suggests to us the intended meaning of "truth"; we sense the emotional importance which Hoffman attaches to truth, but we are irritated and confused by her failure to indicate, explicitly or implicitly, the nature of her referent. Such semantic imprecision corresponds to the least permissible laudatory uses of "beauty" and should be equally condemned.

One again concludes that certain writers are as yet insufficiently aware that the initial requirement in discussions concerning abstract terms is to *give* meanings to them. Consequently, as Richards wittily puts it, "In most arguments, men give their chief attention—not to making open and public the senses which may be best used—but to the attempt to say the right thing about a nothing whose form and qualities are changed with every statement made about it" [93]—a predicament which apparently does not disturb even so eminent a critic as T. S. Eliot, who calmly writes: "But if any one complains that I have not defined truth, or fact, or reality, I can only say apologetically that it was no part of my purpose to do

92. *Sculpture Inside and Out* (New York, 1939), p. 19.
93. *Basic Rules of Reason* (London, 1933), p. 20.

so, but only to find a scheme into which, whatever they are, they will fit, if they exist." [94]

If, however, one understands the need of volitional definitions, important semantic progress will have been made; for in that case any of several definitions of "truth" may be meaningful and feasible. The critical linguistic tasks will be to discover the definitions intended, if not stated, and to decide whether these conform to the general criteria of good definitions listed on page 15. Let us now undertake these tasks with regard to four differing modes of truth.

(B) "Truth" as Scientific Fact

According to the "scientific" notion of truth, truth can be arrived at only by scientific methods, and the term "truth" should therefore be restricted to matters of factual validity. Within this general scientific position, differences of opinion exist concerning the sorts of facts which may be considered true. Should "truth" be applied only to syntactical propositions? Should it be considered as "verifiability"? Or as "warranted assertibility"? Or as some more normative notion, like that of Bertrand Russell, which includes "principles of inference which are neither demonstrative nor derivable from experience"? [95] These and other distinctions—distinctions, for instance, between scientific and historical truth, or be-

94. "The Function of Criticism," *Selected Essays* (New York, 1932), p. 22. Let us observe from the following quotation how horrified John Locke would be at the procedure of Mr. Eliot: "Mixed modes, especially those belonging to morality, being most of them such combinations of ideas as the mind puts together of its own choice, and whereof there are not always standing patterns to be found existing, the signification of their names cannot be made known, as those of simple ideas, by any showing: but, in recompense thereof, may be perfectly and exactly defined. . . . For since the precise signification of the names of mixed modes . . . is to be known, they being not of nature's, but man's making, it is a great negligence and perverseness to discourse of moral things with uncertainty and obscurity" (*An Essay Concerning Human Understanding*, II, 156).

95. *An Inquiry into Meaning and Truth*, p. 383.

tween factual and logical truth—need not detain us, since *for my purposes* all of these views may be grouped together within a broad "scientific" approach to truth, which has for its chief criteria accuracy, testability, and *public* verifiability.

Perhaps that aspect of the scientific position which considers truth *as correspondence* is the one most applicable to art. As William James explains this view: "Truth is essentially a relation between two things, an idea, on the one hand, and a reality outside of the idea, on the other." [96] Though I should substitute the word "proposition" for James's word "idea," the relative clarity and precision of this interpretation of truth must appeal to anyone; and Professor Greene in *his* consideration of artistic truth as correspondence—which is one of his two major criteria of truth—*partially* subscribes to it. "Truth and falsity," he says, "are properties of a proposition according as it does or does not accurately describe what it purports to describe, i.e., the 'object' to which it 'refers.' " [97] Or again, a proposition must " 'correspond' to the 'facts.' It must 'describe' its referendum. What is expressed must in some sense 'conform' to 'what is actually the case.' " [98] Now the phrase "in some sense" in the last quotation is important; for without these words and without Greene's further explanations regarding his correspondence view of truth, one might incorrectly suppose that his position is a thoroughly scientific one similar to that described by William James in the following passage: "I myself agree most cordially that for an idea to be true the object must be 'as' the idea declares it, but I explicate

96. *The Meaning of Truth* (New York, 1932), p. 163.

97. *The Arts and the Art of Criticism*, p. 425. At this point in his argument, Greene makes unfortunate use of verbal legerdemain. Having associated truth with propositions, he proceeds to define a work of art as à "non-conceptual proposition"—a remarkable and unjustifiable procedure which, however, at once gives him the logical right to affirm that works of art are either true or false.

98. *Ibid.*, p. 432. The reason why such frequent reference is made to Professor Greene's analysis of artistic truth is that his discussion of the problem is the most complete and interesting one with which I am familiar.

the 'as' -ness as meaning the idea's verifiability." [99] As we shall later see, however, Greene's position is in no way so simple, clear, and direct as this.

Nearly all critics today will agree, indeed, that such notions as verifiability and factual accuracy are unessential, unimportant and, from some points of view, even inapplicable considerations in artistic creation and artistic evaluation. Only a thoroughgoing naturalism which judges art according to a standard of literal imitation would seriously subscribe to them. Nonetheless an occasional critic of repute will agree with Plato that artists are copiers and will advocate such naturalism: "All a sculpture can do is to recall horseness, and it can do that only by being an exact replica of some living horse, e.g., Haig's 'lean charger.' " [100]

This remarkable statement totally ignores that quality of experience which, for most persons, is an essential requirement in the creation of works of art: namely, the imagination. Thus Delacroix attacks imitative art and gives the artistic imagination an important place in his esthetic. As a telling rebuttal to the above comment of Belgion, consider the following:

Realism should be defined as the antipode of art. . . . What, in sculpture for example, would a realistic art be? Mere casts from nature would always be superior to the most perfect imitation

99. *Op. cit.*, p. 170.
100. Montgomery Belgion, "Meaning in Art," *The Criterion*, January, 1930, p. 209. It is curious that, on occasion, Ruskin's notion of artistic truth seems remarkably "scientific." Though he frequently stresses the importance of artistic imagination, and though he considers imitation the "destruction" and truth the "foundation" of all art, his key criterion of truth is a "faithfulness in representing nature" or an "accuracy of perception" which is publicly verifiable. In *Modern Painters*, he states the purpose of Part II in this way: "I shall look only for truth; bare, clear, downright statement of facts; showing in each particular, as far as I am able, what the truth of nature is, and then seeking for the plain expression of it, and for that alone" ([new ed. New York, 1873], I, 115).

which the hand of man can produce: for can one conceive a case in which the mind would not guide the hand of the artist and will anyone believe it possible, likewise, that, despite all attempts to imitate, he will not tinge his singular work with the color of his mind? [101]

Similarly we may say that the artistic imagination crucially affects even the most "realistic" types of worthy drawing and painting. When Mr. Berenson, in discussing the drawings of Andrea del Sarto, remarks upon their "unsurpassed faithfulness to the thing seen," he does not mean that the drawings are exact replicas of nature; for in another place he calls them "matchlessly vital transcripts of reality," thus indicating a high admiration for these sketches as well as an awareness of their sparkle and vitality.[102] Or when Mr. Hagen speaks of the "physiological and psychological truthfulness of the great Realists, Ribalta, Roelas, and the older Herrera," [103] he is not referring—or at least he should not be—to a slavish reproduction of nature; for even these realistic painters (whom, incidentally, I consider minor rather than "great") have transformed their models by imbuing them, to a degree, with imaginative force and energy. Or again, far from being mere copies of reality, are not the meticulously rendered details in the painting of Jan van Eyck fresh and vivid re-creations? One may differently describe this important distinction between

101. *The Journal of Eugène Delacroix* (New York, 1937), pp. 665–666. Walter Pach, trans.

Likewise the world of the poet, to quote D. G. James, "is, of course, personal to him, the creature of a unique imagination synthesizing its own experience of life. . . . Hence verisimilitude is a quite useless concept; indeed it is that which must be abandoned—for of what can poetry be an imitation, except of a world which is personal to a unique imagination?" (*Scepticism and Poetry* [London, 1937], p. 51).

102. The discussion of the drawings occurs in Bernard Berenson's book *The Drawings of the Florentine Painters* (Chicago, 1938), pp. 269–294.

103. Oscar Hagen, *Patterns and Principles of Spanish Art* (Madison, 1936), p. 192.

nature and *any* worthy artistic product by saying that the latter has "style"; it bears the "imprint," in Mr. Morey's words, "of a point of view."

If we agree upon the existence of the creative imagination in the making of all art objects and upon the resultant contrast between these objects and their models in nature, we shall decide—even without considering the many "formal," "plastic," or "esthetic" elements by means of which the artist transforms his material into works of art—that truth interpreted scientifically is of slight importance in any sensible esthetic system. We shall probably agree with Hegel (who of course claimed that the function of art is to reveal a very different kind of truth) that art *qua* imitation is (i) superfluous labor, (ii) inferior to nature, (iii) boring or repellent, (iv) destructive of taste and beauty, and (v) impossible in architecture, music, and poetry. And we shall thus conclude that the scientific mode of truth, while immensely useful to scientists and philosophers, is, *when applied to artistic creation* and judged by Reid's criteria of a good definition, neither "convenient," "useful," nor "conformable to established usage."

(C) "Truth" as Artistic Sincerity

According to another and very different interpretation of "truth," art and truth are closely wedded. Thus for Stace, true concepts "form the main content of art";[104] and for Collingwood, "Art is not indifferent to truth; it is essentially the pursuit of truth." [105] These remarks agree, then, in regarding truth as something decidedly significant for art. But what, exactly, is meant by this sort of truth? The likely answer, I shall try to show, is "sincerity."

In discussing Stace's account of beauty, we observed the im-

104. *The Meaning of Beauty*, p. 223.
105. *The Principles of Art*, p. 288.

portance of "an intellectual content, consisting of empirical non-perceptual concepts." Elsewhere in *The Meaning of Beauty*, we learn that these concepts must be "true"; and in the description of these true intellectual concepts, the major point emerges that any number of apparently *conflicting* concepts may be *equally* true and that, therefore, all works of art are true which reflect any genuinely held attitude whatsoever toward life:

Both pessimism and optimism are justifiable and true conceptions of the world, although they are formally opposed. Life is glad; and life is also sad and miserable. Life is tragic, comic, gloomy, joyful, sordid, sublime, serious, ridiculous, pathetic. Since all these attitudes to life are genuine and true, any or all of them may form the content of beautiful art.[106]

Now if these varying attitudes toward life, which Stace elsewhere calls "intellectual reactions," have a common property by virtue of which they are all "genuine and true," I suggest that this property may be conveniently and usefully defined in terms of sincerity.

While Collingwood's notion of truth agrees perfectly with the foregoing one, he explains it in terms of the emotions. A faithful follower of Croce, he is at pains to dissociate intellectual truth from an intuitive kind which for him is of far greater importance. As with Stace, however, it is the genuineness of one's personal reactions, whether they are called intellectual or emotional, which forms the primary content of truth and of art:

A poet who is disgusted with life to-day, and says so, is not saying that he undertakes to be still disgusted to-morrow. But it is not any the less true that, to-day, life disgusts him. His disgust may

106. Stace, *op. cit.*, pp. 218–219.

be an emotion, but it is a fact that he feels it; the disgustingness of life may be an appearance, but the fact of its appearing is a reality.[107]

Without in any way questioning the subjective validity of these "emotional facts," many people will contend that this subjective validity entails nothing whatever about any "reality outside the idea," and that, therefore, Collingwood's notion of truth, if judged by a criterion of correspondence, is decidedly inadequate. Moreover (to refer again to our criteria of a good definition), however "clear and intelligible," "convenient" and "useful," and "conformable to established usage" this notion may appear to some people to be, I hold that, while Collingwood, like Stace, seems reluctant to use the word "sincerity"—is this not merely because the term has too weak an emotional connotation?—nonetheless "emotional sincerity" characterizes well the brand of truth asserted by Collingwood. Specific evidence for this interpretation may be noticed in the juxtaposition of the following two phrases, the former being the only instance known to me of the use of "sincerity" in either of the books in question: (a) "The perfect sincerity which distinguishes good art from bad";[108] (b) "Its artistic merit and its truth are the same thing." [109] In other words, "perfect sincerity" is implicitly identified with "truth."

Croce, to whom both Stace and Collingwood are indebted, explicitly speaks of sincerity as "fulness and truth of expression." [110] Thus despite certain variations between them, the conceptions which these three writers hold of artistic truth

107. Collingwood, *op. cit.*, p. 288. Similarly Mr. L. A. Reid holds that "the criterion of the truth of art" consists of "the feeling—experience itself" (*Knowledge and Truth* [London, 1923], p. 231).

108. *Ibid.*, p. 115.

109. *Ibid.*, p. 287.

110. *Aesthetic*, p. 88.

fundamentally and essentially seem to correspond with one of Richards' definitions of sincerity: namely, "To be sincere is to act, feel and think in accordance with 'one's true nature.' " [111] Occasionally, indeed, a writer will directly declare that truth in art is equivalent to this sort of sincerity. For example, T. S. Moore states: "Truth in a work of art is sincerity. That a man says what he really means . . . is all that reason bids us ask for." [112]

Because no competent critic would contest the desirability or even the necessity of artistic sincerity, one may regard this kind of truth in art as being virtually obvious. In no way, however, does this imply that it is unimportant. No less an artist and critic than Henry James has spoken of "the one measure of the worth of a given subject, the question about it that, rightly answered, disposes of all others—is it valid, in a word, is it genuine, is it sincere, the result of some direct impression or perception of life?" [113] But it is noteworthy that James avoids using the word "true"; and he does so wisely. For the terms "genuine" and "sincere" are more direct and explicit, less ambiguous and controversial than the word "truth." Therefore, if the meanings are identical, why not consistently employ the former terms as descriptive epithets and delete "truth" entirely when the artistic criterion in question is being discussed?

(D) "Truth" as Artistic Consistency

The notion of truth as "consistency" has provided another ground for considering truth a major artistic criterion. According to this idea, artistic creations are "true" because of their "artistic probability" or "internal necessity." "Artistic truth" refers to the internal structure, to the total coherence

111. *Practical Criticism*, p. 289.
112. *Albert Durer* (New York, 1905), p. 19.
113. *The Art of the Novel* (New York, 1934), p. 45.

and connectedness of elements in a work of art; it is "the inner law which secures the cohesion of the parts." [114]

To explain this view, the core of Professor Greene's elaborate account may be summarized. "By consistency is meant, in general, the satisfaction of the several conditions requisite to the clear expression of ideas in any medium." [115] There are four of these conditions.

(1) "Medial" or "linguistic correctness" is the negative criterion stating

the artistic requirement of conformity to relevant pre-artistic and artistic rules and conventions. A work of art satisfies this criterion in proportion, first, as the basic principles of the chosen medium are not violated, and, secondly, in proportion as the formal implications of the manner or manners of treatment, and of the compositional pattern, adopted in it, are not disregarded.[116]

Thus a fresco which was begun with miniaturelike detail and which was completed in mosaic, gouache, and water color would violate artistic rules and conventions; and a painting which was executed partly in the "mode of line and local tone," partly in the "mode of relief," partly in the "Venetian mode," and partly in the "mode of total visual effect," [117] would outrageously disregard formal pictorial principles.

(2) "Medial" or "linguistic felicity" is the positive criterion stating that an artist has not expressed himself with felicity if

114. S. H. Butcher, *Aristotle's Theory of Poetry and Fine Art* (4th ed. London, 1932), p. 166. Although Butcher at no point in the discussion of Aristotle's view of poetic truth uses the term "consistency" to describe this view, the meaning of such epithets as "artistic probability" and "internal necessity" is essentially similar to Greene's meaning of "consistency" which will now be considered.

115. *The Arts and the Art of Criticism*, p. 429.

116. *Ibid.*, p. 447.

117. These are the artistic categories discussed by Professor Arthur Pope in *The Painter's Modes of Expression* (Cambridge, Mass., 1931).

he has "failed to exploit adequately the expressive potentialities of his medium. His work may be correct in a negative sense without being positively felicitous or inspired." [118] Thus a work of art which reveals genuine artistic imagination, fertility in invention, and marked originality is felicitous by contrast with a work which is relatively unimaginative, merely correct, and imitative. This distinction is often found when the works of a master, say Bernini, are compared with those of his followers.

(3) "Ideational non-contradiction" is the negative criterion according to which the

interpretations of the subject-matter do not contradict one another. . . . To illustrate this type of contradiction in an extreme, indeed, a fantastic manner—suppose we were to find in a single composition different representational objects treated in the manner of Corot, Cézanne, Matisse, and Henri Rousseau. The result would be utter ideational chaos. We would exclaim: "The painter has contradicted himself in almost every stroke." [119]

(4) "Ideational coherence" is the positive criterion which

is achieved only in proportion as all the interpretations of the several portions of the specific subject-matter *complement* one another so that the work of art as a whole expresses a complex and coherent commentary on the nature and import of the entire subject-matter in question. Every great work of art which is stylistically consistent through and through exemplifies such artistic coherence, as is evidenced by the sense of organic unity of outlook which we derive from it.[120]

Although one might plausibly argue that the foregoing criteria are too conservative or respectable since sometimes works of art seem successfully to violate one or more of them

118. Greene, *op. cit.*, p. 448.
119. *Ibid.*, pp. 449–450.
120. *Ibid.*, p. 450.

(e.g., certain Gothic cathedrals in their stylistically variegated ensembles); and although a distinguished writer or artist occasionally even opposes these criteria (e.g., Delacroix in his suggestion that the joining of the styles of Michelangelo and Velasquez would be "a strange thing, and a very beautiful one"); nonetheless the four conditions of consistency are so described and illustrated by Mr. Greene that few art critics or estheticians will disagree either with his analysis of these elements or with his affirmation of their importance for artistic creations. But why is this artistic criterion of consistency connected with the word "truth"? I do not believe that sufficient historical justification can be found in the writings of philosophers, artists, art critics, or art historians for such usage, and surely few people today would think of associating the four artistic criteria of consistency, or the combination of them into what Greene calls "stylistic excellence," with "truth."

Why, then, does Greene urge these unusual associations? In addition to what seems to be a pervading passion for the word "truth," there are perhaps two reasons why he calls artistic consistency "artistic truth": first, because of the identification he makes between works of art and (non-conceptual) propositions which, according to his definition, are the locus of truth;[121] second, because of the connection between "truth" and the consistency of logic. But these connections between truth and non-conceptual propositions and between truth and logic seem to indicate not that artistic consistency should be called "artistic truth," but rather (a) that a work of art cannot reasonably be called a proposition, and (b) that the nomenclature of one sphere of discourse is not necessarily applicable to another: that is to say, since "artistic consistency" is in fact not at all the same as "logical consistency" (the latter

121. See n. 97.

being wholly a question of following certain explicit rules),
it is unjustifiable to use the connection between "logical con-
sistency" and "truth" as an argument for defining "artistic
consistency" as "truth." In short: while there is no decisive
reason for rejecting the usage of the phrase "artistic truth" to
mean artistic consistency, there is nothing to be said in its
favor. My conviction is that it will find little acceptance with
estheticians and critics and that, therefore, the whole discus-
sion of consistency *in any connection with "truth,"* is super-
fluous and unfortunate.

Moreover, as noted above, there are other terms less equivo-
cal in character than "truth" which one may use in criticism
to evoke Greene's idea of artistic consistency. For example,
"artistic probability" or "internal necessity" or Greene's own
phrase "stylistic excellence" seem preferable; and Richards
has suggested the expressions "internal acceptability," "right-
ness," and "convincingness," [122] which mean approximately
what Greene intends by his criterion for truth of consistency,
and which may likewise be analyzed into Greene's four requi-
site conditions of consistency. Therefore, since the use of
"artistic truth" in the sense of artistic consistency is uncom-
mon, and since there are a number of expressions which con-
vey the idea with somewhat greater precision, the notion of
artistic consistency *as truth* should be relinquished. To be
sure, the intended idea is artistically an important one, but
the use of "truth" to explain it seems unnecessary and arbi-
trary, hence undesirable. If, indeed, we once more apply our
accepted criteria of good volitional definitions, I believe we
shall conclude that Greene's definition, while sufficiently
"clear and intelligible," is neither "as convenient or useful as
possible in dealing with a given subject-matter," nor as nearly
conformable "to established usage, if any, as is compatible
with clarity and usefulness in the context."

122. *Principles of Literary Criticism* (New York, 1926), pp. 269-270.

(E) "Truth" as Artistic Insight

So far in this analysis of truth as an artistic criterion, we have distinguished between four uses of the term "truth," i.e., "truth" as an undefined term, as "scientific fact," as "sincerity," and as "consistency"; and we have found reasons of varying sorts for being dissatisfied with each of these uses. A fifth (and final) use, which we shall now consider at some length and which we shall call truth as "artistic insight" or "artistic revelation," is a complicated one, difficult to analyze.

As a starting point for the discussion, consider the interesting and illuminating views recently expressed by Professors Greene and Irwin Edman.[123] These writers agree upon one important matter: namely, that a work of art presents more than a pleasing surface pattern, that it "says something," and that, therefore, it should not be judged solely by formalistic standards. They assert that art-objects have "the character of revelation," and offer "new insights, new observations, new interpretations, new appraisals of a more or less familiar subject matter"; or, as stated in the familiar controversial terminology, an art-object "rings true," is "true to our experience," or is "poetically true."

Let us make the assumption, which I believe is a valid one, that the majority of expert critics[124] agree with the foregoing general critical position. Two related questions of considerable interest and importance may then be asked: first, precisely what is meant by the phrases just quoted? second, can they reasonably be subsumed under a general category of truth in art?

In order to answer these questions, let us begin by asking specifically: what is the nature of the religious insights and

123. These occur in *The Arts and the Art of Criticism*, chap. xxiii, *passim;* in *The Art Bulletin*, December, 1940, pp. 274–276; and in *The Art Bulletin*, March, 1941, pp. 80–81.
124. The qualifications of the expert critic are described on pp. 92–93.

revelations expressed by Rembrandt's "Supper at Emmaus" in the Louvre? and in what critical terms may one best analyze the religious wonder and mystery which seem to pervade that picture? These insights and revelations, in the first place, have little, if anything, to do with verifiable facts; the question of historical accuracy, i.e., the question of perhaps the most relevant sort of "scientific truth," is of negligible artistic interest. In the second place, the "artistic consistency" of the painting, though highly important if one is evaluating the work as a whole, may be ignored in the present context, for this consistency is not, primarily at least, in question. And in the third place, the "new observations, new interpretations, new appraisals" portrayed by Rembrandt do not *merely* express the artist's sincere emotions or ideas; they seem to *correspond* in *some* way, to *some* kind of objective actuality. Thus, though one will observe in what follows that the theory of truth as artistic insight approximates the views of Stace and Collingwood in that, like them, it stresses, as the key criterion of truth, the validity of personal reactions; nonetheless these two views are unlike in that the "sincerity" position stresses the "genuineness" of the *artist's* personal reactions, whereas the "insight" position accents the "genuineness" of the *meanings* revealed by the work of art to qualified observers.

One may illustrate this distinction between the "sincerity" view and the "insight" view by remarking that an inferior artist may deeply feel and sincerely express artistic meanings which the judicious critic will find insipid, trivial, sentimental, and the like. Moreover, when Clive Bell remarks that Fra Angelico "is never inadequate to his problem, that of telling the truth about the emotional significance of things," [125] he is not referring to the sincerity of Fra Angelico's emotions; rather, he is affirming that painter's ability to reveal some-

125. *Enjoying Pictures* (New York, 1934), p. 59.

thing "true" about *things*. Similarly one might say that Masaccio in the Brancacci chapel is not merely being sincere; he is expressing a physical and moral grandeur which "rings true" to our experience of the noblest human beings. And when Susanne Langer states that "music can *reveal* the nature of feelings with a detail and truth that language cannot approach," [126] she explains this fact by the greater congruence of "musical forms" with the "forms of human feeling"; in using the word "truth," she is referring to a correspondence between certain artistic "forms" and a certain sort of reality.

The wonder and mystery expressed in the Rembrandt, then, convey to many sensitive people insights or revelations of reality. The "ideas" in the painting seem to correspond with an actuality outside of the ideas. Since, however, this correspondence between these insights or revelations and this actuality is not a scientifically or publicly testable one, the crucial questions arise: what is the ontological status of unverifiable insights, beliefs, intuitions, and so forth? and how may they most accurately be described? At this point we encounter five problems of critical importance which will be briefly considered in order to illuminate, in various ways, the problem of truth as artistic insight.

(*1*) *Intuitive and Conceptual Truth*

Most philosophers probably agree that truth may *in some sense* be predicated of the results produced by the activity of the "intuition" or "imagination." Most philosophers probably also agree that *some* broad distinction should be made between "intuitive" or "imaginative" truth, on the one hand, and "scientific," "conceptual," "demonstrative," "logical," or "intellectual" truth on the other.[127] In whatever precise terms

126. *Philosophy in a New Key*, p. 235.
127. The term "knowledge" might, of course, be substituted in this context for "truth." But it seems unnecessary to complicate this discussion by considering the possible relationships between truth and knowledge.

this distinction is stated, the artistic insights under discussion, if characterized as "truth" at all, will be characterized as a kind of intuitive or imaginative truth. Thus according to Aristotle, poetic truth transcends facts, transmuting them into imaginative truths; for him, poetry is an expression of a reality higher than fact, is a "concrete embodiment of universal truths," and "represents things which are not, and never can be in actual experience." [128] Or again, works of art will offer revelations or intuitions of truth for those who, like Schelling, claim that the imagination is the organ of truth, or for those who, like Coleridge, claim that "all truth is a species of Revelation." A similar position is taken by Professor Greene, who holds that "individual intuitions, in any universe of discourse, may be final and complete *within a limited frame* of reference," [129] and that artistic intuitions may be called "absolute" and "true." For Greene, in short, artistic truth may be revealed by right intuitions, and these can be tested in the last analysis only by direct observation and scrutiny.

The important question: is it desirable to consider intuitive truth and artistic insights in terms of "truth" or of another word? is too immense to be argued at length here, but one quite obvious objection to this usage of "truth" may be mentioned: namely, the desirability of distinguishing verbally between scientific and intuitive truth, between truth which is relatively stable, predictable, verifiable, and generally agreed upon, and truth which is unstable, unpredictable, unverifiable, and only personally binding.[130]

128. Butcher, *Aristotle's Theory of Poetry and Fine Art*, p. 168.
129. *The Arts and the Art of Criticism*, p. 456.
130. Even Professor Greene explains as a "notable difference" between scientific and artistic truth the fact that artistic truth applies only to an "individual frame of reference" (*ibid.*, p. 459). But what Greene ignores is the notorious fact that one's "genuine intuitions" may rapidly and completely change. Consider, as an example, the contrasting insights toward his beloved of a man "in love" one month and "out of love" the next. Equally

If this contrast between the two types of truth is blurred or ignored, confusion and ambiguity in regard to the meaning of "truth" will almost inevitably occur. What I would insist upon is that the distinction is a real and important one which should be clarified by verbal means.[131] What specific means should be adopted is, up to a point, an arbitrary matter. One might consistently apply the terminology "truth[1]" and "truth[2]." Or one might call intuitive truth "truth," and scientific truth "fact." In this case, however, countless persons would resent being forced to admit, say, that "genuine intuitions" both for and against the existence of God, or both for and against the "essential dignity of man," are equally true. For such persons, the "immense and exquisite correspondence" which Henry James found between fiction and life presents not "truth," but—as for James—an "air of reality." By

notorious is the fact that the "genuine intuitions" of different, yet equally sensitive and intelligent people conflict. Consider the fundamental creed of a Christian as opposed to that of a naturalist. If such facts are remembered, surely "truth as intuition" becomes a remarkably unreliable and unstable concept. One escape from this dilemma is the attempt to reconcile as "true" all of the varied and opposed interpretations of reality by predicating some ultimate harmony in the universe which underlies all apparent differences; but this is an unverifiable dogma which the experience of most persons flatly contradicts. Another more reasonable escape interprets truth in entirely personal terms (i.e., as "my discovery of reality"), and so frankly admits that contradictory truths do exist. But most persons today, I believe, are equally reluctant to accept this usage. For these reasons, as well as for the one given in the text, I agree with those who think that intuitive truth and artistic insights are more intelligibly and conveniently defined as "beliefs" rather than as "truths."

131. The need for some verbal distinction may be further emphasized by a quotation from I. A. Richards: "To ask 'Is this so?' of 'A man is an immortal spirit,' 'Two and three are five,' and 'Water freezes at 32° F.' is to ask three quite distinct types of question, as we may see by considering what steps would be appropriate in answering them. In the senses in which we will agree that the second and third are true, it would be nonsense to say that the first is. We have neither made man immortal by definition and tautology, nor have we established his immortality by experimental measurement" (Coleridge on Imagination, p. 147).

no means compulsory, therefore, but on the whole preferable, in my opinion, would be a verbal distinction between scientific truth as "truth" and intuitive truth as "belief." [132]

The linguistic problem we have been considering, however, can never be definitively settled because of its dependence upon irreducible philosophical convictions: one's notion of truth will largely depend upon one's ideas about cognition and reality. This being so, I am aware that my preference regarding the terminology of explanation is not an impartial one, but is influenced by my general philosophical system of acceptances which might be roughly labeled "empirical nominalism." According to other differing systems of acceptances, the word "belief," which unlike "truth" is not weighted with positive values and which may even be weighted with negative ones, lies below the level of these acceptances and is therefore an inadequate index of them. In these systems, therefore, two quite contrasting senses of "truth," even though muddling and misleading in discussion, will probably be inevitable; or else, perhaps, these systems will not apply the term "truth" àt all to scientific fact.

(2) *Emotive and Referential Discourse*

An analogous approach to the problem of truth as artistic insight is suggested by I. A. Richards's much-discussed and already mentioned distinction between referential and emotive discourse. The former stands for scientific facts or "verifiable

132. Of course the word "belief" is as much of an abstraction and as difficult to analyze as is the word "truth." For example, a broad distinction is frequently made between rational or conceptual beliefs, and intuitive or impulsive ones. Usage seems to indicate, however, that truths are more permanent, fixed, and stable than are beliefs. A "belief" seems to me well defined as " (1) entertainment of a proposition *p,* and (2) a disposition to act as if *p* were true" (R. B. Braithwaite, quoted by D. G. James, *Scepticism and Poetry,* p. 67).

beliefs" (i.e., for the "Sense" of the "total meaning"); the latter expresses emotional experience or offers "imaginative assents" (i.e., the "Gesture" or "intention, feeling and tone" of the "total meaning"). More recently, Bertrand Russell has urged this difference by contrasting propositions which "indicate facts" with those which "express states"; and D. G. James makes the following somewhat different distinction, which seems to me exceptionally illuminating: "The true distinction is between language having reference in the last resort only to sense-data, and used therefore for purposes of barest indication, and language used *imaginatively*. For in poetry the poet endeavours to convey his sense of the inner unity and quality of the object as embracing and transcending what is given in sense." [133]

Now these differentiations are not or should not be intended to imply that the two uses of language (however the differentiation between them is exactly explained) can be rigidly pigeonholed as separate and alternative. Admittedly they "usually occur together" since "some element of reference probably enters . . . into almost all use of words." [134] Nonetheless the distinction is a valuable one and has a bearing upon the problem of verbal truth. If it is opposed or ignored, confusion concerning truth will follow, as I shall presently try to show; if it is accepted, the verbal distinction between "truth" and "belief," already urged, may likewise be accepted (as is the case with the writers mentioned in the preceding paragraph) as a clear and logical way of differentiating two kinds of discourse. Indeed this distinction between these two uses of language seems to challenge the definition of artistic insights as "truths," since the meanings of these insights are largely evocative, expressive, imaginative, unverifiable,

133. *Op. cit.*, p. 30.
134. Ogden and Richards, *The Meaning of Meaning*, p. 150.

and the like; or, to express the matter otherwise, the concept of truth as artistic insight is perhaps misleading, since it does not sufficiently take into account the foregoing linguistic distinction. A specific illustration will make this clear.

In an essay, "On the Semantics of Poetry," [135] Philip Wheelwright opposes Richards' distinction between referential and emotive discourse. He grants to begin with, however, that *some* distinction should be made between what he calls "literal and poetic statement," between uses of language which are "purely referential" and those which are "to some degree reflexive and evocative." He then asks and answers an important question: do the poetic statements "involve any sort of truth and falsity at all? I think they do, and it is important to see in what sense this is possible; in what sense there can be such a thing as poetic truth, distinguishable from and unexchangeable with any strictly logical truth." [136] His argument then urges that to consider poetry in the light of Richards' distinction between literal statements, which are primarily referential and verifiable, and pseudo or poetic ones, which are primarily emotive and unverifiable, is a mistake. He suggests, rather, that the differences between the two kinds of language "are differences of what may be called *assertive weight*. A literal statement asserts heavily; it can do so because its terms are solid. A poetic statement, on the other hand . . . has no such solid foundation, and affirms with varying degrees of lightness." [137] Now this distinction, which Wheelwright elaborates most interestingly, may be[138] useful and important for criticism; but I would ask: does it in any

135. *The Kenyon Review*, Summer, 1940, pp. 263–283.
136. *Ibid.*, pp. 270–271.
137. *Ibid.*, p. 274.
138. "May be," since I believe that Wheelwright's distinction requires further explanation and considerable qualification. Can all dramatic poetry be said to "assert lightly"? Is the content of many Shakesperean soliloquies in any sense "fragile"?

way contradict the view of Richards? Does it not rather ap-
proach the same problem from another point of view which,
for Wheelwright, is a more valuable one? [139]

However that may be, the conclusion I wish to stress is that
Wheelwright's distinction is confusing rather than helpful in
regard to the problem of truth as artistic insight, for it at once
claims validity for "poetic truth," yet fails to explain with pre-
cision either the meaning of this kind of truth or the relation
which it bears to the two types of language just considered. All
we learn is that a poetic statement, by comparison with a
logical one, "does not assert its claims so heavily as a proposi-
tion; its truth is more fragile." [140] But what, exactly, is meant
by "fragile truth" and what relation does it bear, on the one
hand, to scientific facts and, on the other, to "imaginative
assents"? The mere notion of fragility leaves the crux of the
matter unanswered, and to suggest, as Wheelwright does, that
these relationships are unimportant considerations for art is
to ignore questions central to the meaning of "truth." Finally,
I suggest that here and elsewhere[141] Wheelwright's vagueness
regarding his interpretation of truth results from his organic

139. It is worth inquiring to precisely what extent the disagreement be-
tween Wheelwright and Richards is verbal. I incline to believe that Wheel-
wright's concept of poetic truth is in fact remarkably similar to Richards'
concept of "imaginative assent." For example, in a discussion of the line from
"*Macbeth*": "What bloody man is that?" Wheelwright remarks that the literal
meaning of "bloody" requires no comment, and then proceeds to consider the
imagistic and symbolic significance for the entire play of "bloody." Now the
point I would urge is that this "imagistic and symbolic significance" ad-
mirably illustrates what Richards means by the "Gesture" as opposed to the
"Sense" of a work of art; it performs precisely the function which Richards'
pseudo-statements perform, i.e., "it suits and serves some attitude or links
together attitudes which on other grounds are desirable" (quoted by Wheel-
wright, p. 271).

140. *Ibid.*, p. 275.

141. See "The Failure of Naturalism," *The Kenyon Review*, Autumn, 1941;
"Poetry, Myth and Reality," *The Language of Poetry* (Princeton, 1942);
"Religion and Social Grammar," *The Kenyon Review*, Spring, 1942; and "A
Preface to Phenosemantics," *Philosophy and Phenomenological Research*,
June, 1942.

view of meaning, which offers us real, rather than volitional definitions.

(3) "Willing Suspension of Disbelief"

The critical problem of the "willing suspension of disbelief" is one which affects the ontological rather than the linguistic aspect of the mode of truth under consideration. Since this problem deals with the clash between the point of view of the "beliefs" mediated by the work of art and the point of view of the "beliefs" held by the critic of the work of art, the important questions are: can intellectual understanding and imaginative assent be given to artistic contents or meanings which are not shared or accepted as one's own? and, if this is possible, does or should a disbelief in these contents or meanings affect one's appraisal of them—e.g., can an atheist expertly appraise Rembrandt's "Supper at Emmaus"? The diversity of responses to these questions is interesting and illuminating (though art criticism has shown too little concern with this problem), but only their connection with the conception of truth as artistic insight need now be mentioned.

If, as many competent writers contend, the beliefs of the artist—by which I now mean to include all of his conceptual and intuitive convictions—need *not* be shared by the critic in order that he may appraise a work of art expertly, truth may reasonably be claimed for the artistic insights by those who choose to define "truth," at least partially, in terms of intuition; for in that case the critic's concern will be imaginatively to prehend the work of art. His own convictions will be artistically irrelevant and, by suspending disbelief for the time being, he will judge the truth of the artistic insights on the basis of the *artist's* standards. Thus in judging the sensuousness of Rubens' art, a puritan critic may hold his own beliefs in abeyance, may at least understand the insights which Rubens wishes to convey, and may appraise these as truths on the basis

of Rubens' experience of life. In defending this solution to our problem, T. S. Eliot asserts:

My point is that you cannot afford to *ignore* Dante's philosophical and theological beliefs, or to skip the passages which express them most clearly; but that on the other hand you are not called upon to believe them yourself. . . . For there is a difference . . . between philosophical *belief* and poetic *assent*. . . . You are not called upon to believe what Dante believed, for your belief will not give you a groat's worth more of understanding and appreciation; but you are called upon more and more to understand it.[142]

But if, as other competent writers hold, the beliefs of the artist must be shared and accepted by the critic in order that he may appraise expertly, the truths expressed as insights in the object cannot be considered artistically pertinent or meaningful; for in that case, judgment upon the truth of these insights will be passed on the basis of the *critic's* standards; and the critic will not be able or willing to appreciate or apprehend the insights sympathetically unless they by chance coincide with his own truths or beliefs. Thus the puritan critic will judge Rubens solely on the basis of his own puritan criteria and will find no truth in that artist's sensuously expressed insights. Or, as J. C. Ransom attacks the passage of Eliot just

142. "Dante," *Selected Essays*, pp. 218–219. In *Archetypal Patterns in Poetry* (London, 1934), Maud Bodkin holds that the apprehension of poetic truth involves no "suspension of disbelief" but rather promotes a "quickening of belief" which comes from the poetic revelation of some actual and recurring phase or element of life. It seems to me, however, that the notions of "suspension of disbelief" and "quickening of belief" are, in at least one important sense, complementary rather than antithetical: for example, the painting of Rubens and the poetry of Dante can quicken the respective beliefs of puritan and heathen critics *only after* these critics have suspended their own disbeliefs. No doubt much of the difficulty in reaching an agreement upon this relationship between the two notions is caused by slight variations in meaning which the term "belief" receives.

quoted: "I can see no necessity for waiving the intellectual standards on behalf of poets. If Dante's beliefs cannot be accepted by his reader, it is the worse for Dante with that reader, not a matter of indifference as Eliot has argued. If Shelley's argument is foolish, it makes his poetry foolish." [143]

A third alternative, held by still other competent critics, suggests an intermediate position between the two foregoing ones: namely, that the critic should judge the truth of the artistic insights on the basis *both* of the artist's standards and of his own. Thus Norman Foerster states:

Let me explain by describing how, it seems to me, a good critic will read a book new to him. He will read it in two ways, first one way and then the other, or else in the two ways simultaneously. One way we may speak of as 'feeling the book,' the other as 'thinking the book.' By feeling the book I mean passively responding to the will of the author, securing the total impression aimed at. If the book accords with the critic's tastes and beliefs, this will be easy; otherwise, he will have to attempt an abeyance of disbelief, a full acceptance of the work for the time being, in order to understand it. But understanding is not criticism, and therefore he must read it another way, 'thinking the book,' that is, analyzing closely the esthetic pattern and the ethical burden, and reflecting upon these in terms of his criteria until he is ready with a mature opinion of the book's value. If obliged to suspend disbelief when reading the first way, he is now obliged to state and justify his disbelief.[144]

143. *The New Criticism*, p. 208. That the view expressed by Mr. Ransom is not entirely exceptional may be seen from the following extraordinary words of W. H. Auden: "The poem ["The Waste Land"] is about the absence of belief and its very unpleasant consequences; it implies throughout a passionate belief in damnation: that to be without belief is to be lost. I cannot see how those who do not share this belief, those who think that truth is relative or pragmatic, can regard the poem as anything but an interesting case history of Mr. Eliot's neurotic state of mind" ("Criticism in a Mass Society," *The Intent of the Critic*, pp. 140–141).

144. "The Esthetic Judgment and the Ethical Judgment," *The Intent of the Critic*, p. 85.

According to this theory, then, the relevancy of artistic insights as truths will take a position midway between the two preceding attitudes: while "feeling the book," the critic will respond sympathetically to the insights of the artist and will at that moment grasp their intuitive truth value; but while "thinking the book," the critic will probably alter his appraisal and will be unwilling to recognize the artistic insights as truths unless, again, they by chance coincide with his own convictions. Thus in this case, the puritan critic of Rubens will react in two ways: first, judging on the basis of Rubens' intention, he will understand and will emotionally and sympathetically respond to the artist's sensuous expressiveness; second, judging on the basis of his own criteria, he will deny that this expressiveness reveals truth. In summary, we may say that the solution to the critical problem of the "willing suspension of disbelief" directly affects the importance of the notion of truth as artistic insight; the solution, however, does not affect the reasonableness of defining these insights as "truths."

(4) "Artistic Significance" and "Truth"

The problem of truth as artistic insight is affected, again, by the concept of artistic "significance," "importance," or "greatness." Artistically we are concerned not only with the truth or belief value of insights (if, indeed, that problem concerns us at all), we are concerned with insights that are *significant*. Now significance is an artistic criterion which some persons do not accept and others do not understand. The problem of whether or not to *accept* this criterion is primarily a real one which lies beyond the scope of this book.[145] An *understanding* of the criterion, however, is at this point essential. Such understanding may answer the typical criticism

145. For excellent defenses and analyses of this criterion, one should consult the following books: Greene, *The Arts and the Art of Criticism;* Walter Abell, *Representation and Form* (New York, 1936).

of a friend who remarked that he failed to grasp the distinction between significance and truth, and that I was in fact merely passing over the problems of truth to the word "significance" which seemed to have for me a perhaps magical satisfaction.

A definition of "artistic significance" conceivably could, to be sure, be identical with any one of several definitions of "artistic truth"; but most writers, when they use the term "artistic significance," are referring to the profundity and richness of the artistic meanings or significations; they are pointing to a quality, recognized by many persons, of artistic importance or greatness in contradistinction to that of slightness and triviality; they have in mind the "dignity, elevation, and power" which Longinus stresses in his discussion of the Sublime; in a word, they are considering the major as opposed to the minor. Thus explained, artistic significance is a quality of experience quite other than that designated by any of the senses of "truth" which have concerned us.

To demonstrate this conviction, we may cursorily distinguish between artistic significance as just defined and the five modes of truth under consideration. (a) "Truth" as an undefined term produces ambiguities which prevent one from ascertaining a possible identity of its meaning with artistic significance or, indeed, with anything else; (b) "truth" as scientific fact, far from being confused with significance, is quite regularly opposed to it—as in Bertrand Russell's contrast between "indicating facts" and "expressing states" or between "scientific validity" and "emotional importance"; (c) "truth" as sincerity refers to the subjective genuineness of the artist's attitude and does not concern its importance; (d) "truth" as consistency indicates a quality of artistic "rightness" or "convincingness" expressed in the art object which in no way affects the problem of triviality versus significance; and (e) "truth" as artistic insight considers—or should reasonably do so—the significance or greatness of artistic mean-

ings of subsidiary moment and stresses the necessity of corre-
spondence between these meanings and some objective
actuality, whereas the criterion of artistic significance reverses
the import of these ideas.

Since "truth" as artistic insight is the mode which is most
likely to be confused with artistic significance, it is perhaps
worth pointing to the separation between the two which is
clearly implied in Clive Bell's reference, already quoted, to
Fra Angelico's characteristic of "telling the truth about the
emotional significance of things"; and it is noteworthy that
Greene carefully distinguishes between the concepts of artis-
tic truth and artistic significance and devotes a separate chap-
ter to an extensive analysis of each. By contrast, Langer's
claims that artistic truth has "degrees" and that it is "all sig-
nificance, expressiveness, articulateness," [146] are confusing; in
these claims she is guilty, I believe, of doing precisely what she
has previously condemned in others: namely, ill-defining ar-
tistic truth.

Before considering this standard of artistic significance at
greater length, I must state, briefly, in just what sense I intend
throughout this book to use the slippery words "content" and
"form." By "content" I refer to the innumerable moods
which art objects express: for example, the "energy and
power" of a baroque façade, the "poignant sadness" of Dé-
tente sculpture, the "dignity and aristocracy" of Velasquez'
portraits. So defined, content is something totally different
from the non-esthetic factor of subject matter. Thus the "Last
Supper" as a theme is subject matter which has been inter-
preted and artistically expressed in many different ways. Con-
tent, in short, is synonymous with artistic expression. By
"form" I refer, in a broadly inclusive sense, to the organiza-
tion, ordering, or relationships of elements in art objects.
This organization will include such artistic constituents as
balance, symmetry, and rhythm; and we may call such ele-

146. *Philosophy in a New Key*, p. 263.

ments of form "*formal*." But artistic form or organization need not be restricted to these elements; the concept may refer also to the ordering of such "associated" elements in the realm of artistic expression as action, character, and setting.[147] In this case, we have *associative*, rather than *formal* (or "plastic") form. Associative form is also organization, but it is an organization of elements which pertain to the content. At this point, then, content and form become mutually dependent. And it is true, moreover, that all aspects of form—formal as well as associative—lead directly to, encourage, and stimulate the expressive possibilities of works of art—as, for example, when the compositional rhythmic ordering of a Rubens helps to communicate a mood of exuberant vitality. Form and content, therefore, are tightly linked; yet, since they are basically distinguishable, these two fundamental artistic categories may profitably be differentiated and even considered separately.[148]

We may now explain artistic significance a bit further by listing certain general facts about it and by citing a number of monuments to illustrate it. The general facts are: (i) The

147. For an admirable elucidation of "associative form," the reader should consult Abell, *Representation and Form*, chap. vi.

148. Although many people believe that such categories of analysis are unnecessary, cumbersome, arbitrary, and misleading, I hold that, while form and content truly interpenetrate and while works of art are specific and unified creations which should always be experienced in all their concreteness and individuality, nevertheless a systematic analytical approach which breaks up art objects into constituent elements is a valid and valuable method of thoroughly understanding the works in question. Indeed, "the very word criticism, deriving ultimately from a Greek verb meaning to separate, suggests that the natural, perhaps the inevitable, method of criticizing is to consider separable parts or elements in a poem or picture" (D. A. Stauffer, "Introduction," *The Intent of the Critic*, p. 22). There is evidence, moreover, that great artists sometimes consciously dissociate content and form. Consider, for example, the following remark of Henry James: "It is a familiar truth to the novelist, at the strenuous hour, that, as certain elements in any work are of the essence, so others are only of the form; that as this or that character, this or that disposition of the material, belongs to the subject directly, so to speak, so this or that other belongs to it but indirectly—belongs intimately to the treatment" (*The Art of the Novel*, p. 53).

standard is determined not by the subject matter of the work of art, but *primarily* by the content; thus a dull, insipid portrait of a great man would be less *significant artistically* than an inspired interpretation of a nonentity: paintings of known aristocrats by Sargent are inferior in artistic significance to unknown beggars by Velasquez. (ii) The standard is not to be *wholly* associated with content, since significance of form,[149] though a difficult concept to elucidate, is a noteworthy artistic idea: thus the formal or plastic form of Seurat or Cézanne—their compositions, their use of colors, space, masses, texture, linear rhythms, and so forth—seems richer, higher, or greater than that of Signac or Gauguin. (iii) The standard of significance should not be confused with that of "perfection," which usually refers to the degree of success with which the artist has achieved his several aims: accordingly the fourteenth century Virgin in the south aisle of Notre Dame is no less perfect, though she is less significant, than the Magdalen from the "Entombment" at Solemes. (iv) Interpretations of the standard will inevitably vary since they depend partly upon the total outlook of the individual critic; that is to say, even if the standard is accepted as an artistically legitimate one, qualities in a work of art will vary in their degree of "significance," "greatness," or "profundity" according to differing philosophical and psychological attitudes: thus, to cite an exceptional view of artistic significance, an art historian friend who subscribes to this criterion claims that all landscape painting, by comparison with figure painting, is artistically uninteresting and unimportant. Relativity in the conception of artistic significance, however, seems an inadequate reason for maintaining that the standard is a useless or misleading one.

We may now specifically point to this quality of significance

149. Since I am uncertain about the exact meaning which Bell, Fry, Langer and others attach to the popular epithet "significant form," I do not know whether or not it is identical with the idea mentioned at this point in the text.

by comparing the monuments in the following pairs. In each case, those who accept the standard I have been describing as a valuable one in criticism will agree that, whereas no sensible distinction between the monuments in each pair can be made on the basis of the several foregoing definitions of truth (or, indeed, on the basis of the criterion of perfection as it is usually defined), a valuable distinction urges that the first monument in each pair contains the greater amount of artistic significance: (a) the Parthenon and the Temple of Athena Nike; (b) the "Crusader" of Chartres and a Gothic ivory; (c) an El Greco "Agony" and a Picasso "Abstraction"; (d) Mozart's "Jupiter Symphony" and Prokofieff's "Classical Symphony"; (e) Ibsen's "Ghosts" and Noel Coward's "Blithe Spirit."

Assuming, now, that the meaning of "artistic significance" is sufficiently clear, we may ask: what bearing does this quality have upon the problem of truth as artistic insight? Two observations seem pertinent: (i) There is the danger, noted above, that the idea of artistic truth will be confused with that of artistic significance: thus it may happen that the potency of the term "truth" will mislead one into supposing that what seems peculiarly important is therefore exceptionally true. But if one believes that it is imperative for clear thinking to dissociate importance from truth, then the problem of whether or not artistic insights shall be called "truths" or something else will be settled apart from a consideration of their importance; it will be settled according to certain philosophical and semantic convictions already mentioned. (ii) When significant artistic insights are in question, the problem of truth as insight is of minor interest. Suppose we are considering such insights as the "dignity of man" as revealed in a Raphael portrait, or the "glory of the universe" as expressed by a Cézanne landscape: is it not the significance of these insights rather than their truth which artistically matters? In

fine, I believe that in all works of art which express significance of content or of form, this artistic significance relegates the problem of truth as artistic insight to a position of negligible value—except, of course, for those who reject the foregoing distinction between truth and significance.

(5) Artistic Insight and Ontological Revelation

A final consideration not only challenges the reasonableness of defining artistic insights in terms of "truth"; it supports the above conclusion that these insights, when so defined, become unimportant provided truth as insight and significance are differentiated.

One may explain this consideration, to begin with, by distinguishing between two kinds of symbols: (i) those which connote and denote something that is quite separate from the symbols themselves (e.g., a word or a fire alarm), and (ii) those whose meanings or significations are a part of and are therefore much more intimately connected with the symbols themselves (e.g., a photograph). The distinction, in other words, is "between meanings which are of a generically different character from the symbols that anonymously mean them and meanings whose affinity with the symbols is so close that the symbols are an aspect of, or even tend to become identified with, the meanings." [150]

In the light of this distinction, I suggest that the meanings of truth as ontological revelation and as artistic insight are radically different. If, that is to say, a correspondence view of truth is accepted (and we have seen on pages 66–67 that this view is an essential feature of the definition of "truth" as insight or revelation), and if truth is taken as a symbol, it will then refer to an actuality which bears toward the idea of truth

150. Wheelwright, "Notes on Meaning," The Symposium, July, 1930, p. 381. For the sake of simplification this distinction was not made in the first section of this essay. The only symbols considered in that section were words.

a "spatially distinct, side-by-side, equivalently meant or objective relation of 'correspondence.' " [151] If works of art are taken as symbols, on the other hand, their artistic meanings or values seem so intimately bound up with the objects themselves that external references and associations are esthetically unwarranted. As C. W. Morris explains, while "lyric poetry has a syntax and uses terms which designate things," nonetheless "the syntax and the terms are so used that what stand out for the reader are values and evaluations." [152]

When considering "truth" as scientific fact, we stressed the creative and transforming power of the artistic imagination. If in the present context we do the same, the artistic insights which we are considering appear rather as manifestations of this artistic imagination than as qualities which correspond with any external reality. When Giotto, for example, expresses the deep and tender affection of Joachim and Anna at the Golden Gate, the *correspondence* of this affection to any emotion in real life, I suggest, is an artistically irrelevant matter; what artistically count are rather the innumerable artistic values of the form and content which are revealed by the imaginative freshness, the vividness, and the vitality of the conception. To take another instance: the imaginative expressiveness of the illumination in the painting, say, of Claude, Turner, or Matisse, is an artistic insight or value in relation to which any corresponding external reality (such as is implied by the definition of artistic insight as "truth") seems extraneous and irrelevant.

This contrast between truth as correspondence and artistic insights becomes still more marked of course when the artistic insights are less closely associated with human feelings or natural forms: thus the portraits of Cézanne and the landscapes of Poussin are so highly organized by the artistic imagination,

151. Louis Grudin, *A Primer of Aesthetics*, p. 119.
152. "Foundations of the Theory of Signs," *International Encyclopedia of Unified Science* (1938), I, 58.

and are in consequence so unlike "reality," that an insistence upon any correspondence between them and external actuality would seem singularly inappropriate. In short: although "imagination" plays a paramount rôle both in presenting "truth" as ontological revelation and in expressing artistic insights, there seems to be a notable difference between the two resultant qualities of experience: the *truth as ontological revelation* which the imagination or intuition presents *must* correspond with *some* kind of external reality—with "things as they are"; whereas any correspondence between external reality and the *artistic insights* expressed by the artistic imagination is, according to the theory I am advocating, an unessential or even irrelevant consideration.

Now acceptance or rejection of any linguistic distinction will mainly depend upon one's exact analysis of the qualities of experience involved; the solution to the verbal problem is dependent upon the solution to the real one. Thus Ransom and Auden, I should imagine—judging by their previously quoted insistence that the "beliefs" expressed by an artist must seem true to the critic if he is to understand and appreciate them—would reject the foregoing distinction between the qualities of experience *truth as ontological revelation* and *artistic insights,* and consequently would reject the linguistic distinction. If one accepts the distinction, however, truth as ontological revelation and artistic insights should be verbally dissociated, not identified. And they should be dissociated regardless of one's solutions to the two problems, earlier discussed, concerning the efficacy of defining artistic insight as "truth." Even if, that is to say, one emphatically believes that imaginative or intuitive knowledge should be called "truth"; and even if one rejects the suggested verbal distinction between "belief" and "truth" as a means of clarifying the difference between emotive and referential language; nonetheless the present distinction alone, if it is valid, between imaginative truth as ontological revelation and imaginative artistic in-

sights, cogently challenges the desirability of defining artistic insights in terms of "truth." [153]

To sum up this survey of truth as an artistic criterion: there seem to be at least five uses of "truth" which art critics and estheticians have applied to various aspects of artistic creation and works of art. An attempt to interpret these uses and to indicate the degree of applicability and efficacy that each one has when it is applied as a criterion requiring truth in art, has produced the conclusions (A) that "truth" as an undefined term may cause serious ambiguity; (B) that "truth" as scientific fact designates a referent which is usually either inapplicable to artistic creation or of small artistic importance; (C) that "truth" as artistic sincerity refers to an essential, yet fairly obvious artistic concept, which one may preferably explain by such terms as "sincerity" or "genuineness" rather than as "truth"; (D) that "truth" as artistic consistency refers to an equally essential, but more complicated artistic concept, which one may preferably explain by such terms as "consistency," "rightness," or "convincingness" rather than as "truth"; and (E) that "truth" as artistic insight designates artistic revelations which correspond to a kind of reality or actuality which can be intuitively apprehended, but not scientifically verified.

In analyzing this last mode of truth in order to determine both the desirability of calling it "artistic truth" and its importance as an artistic criterion, we briefly described five varied problems and noted the effects of each upon the conception of "truth" as artistic insight. In so doing, we saw: (1)

153. Some writers who apparently recognize the foregoing distinction between ontological revelation and imaginative artistic insights, nonetheless insist upon calling the latter "truths." L. A. Reid, for example, urges that the truth attained by all creative geniuses "is not in its nature correspondence or coherence but the quality of a vital apprehension, through imagination, of realities which seem to lie beyond the ken of ordinary human mortals" (Knowledge and Truth, p. 11). This possible view invites confusion in regard to truth and fulfills none of the requirements of a good definition.

that the distinction between intuitive and scientific truth suggested a reason for preferring the term "belief" to "truth" to characterize artistic insights, but that this preference was ultimately dependent upon one's basic philosophy; (2) that the distinction between emotive and referential language suggested another reason for preferring the term "belief" to "truth," and that failure to clarify this distinction by verbal means may lead to unfortunate ambiguities; (3) that, regardless of whether the terminology "truth" or "belief" is employed, the solution to the problem of the "willing suspension of disbelief" directly affects the importance of truth as artistic insight; (4) that, again regardless of whether the terminology "truth" or "belief" is employed, the notion of truth as artistic insight tends to become of subsidiary interest when the meaning of "artistic significance" is understood, accepted, and dissociated from the several meanings of "artistic truth"; and (5) that the distinction between symbols which indicate meanings outside themselves and symbols whose meanings are inseparable from themselves, argues further against the *artistic* importance of truth as ontological revelation and seriously challenges the efficacy of calling artistic insights "artistic truths."

This summary is partly intended to underline two points: first, that my initial claim, asserting that many of the difficulties inherent in the problem of artistic truth are semantic, has been substantiated; and second, that a number of varied reasons exist for believing that it is both unnecessary and undesirable to use the epithet "artistic truth" in esthetics and in art criticism.

PART II

PROBLEMS IN EVALUATION

"The notion that valuations do not exist in empirical fact and that therefore value-conceptions have to be imported from a source outside experience is one of the most curious beliefs the mind of man has ever entertained" (John Dewey, *Theory of Valuation*).

" 'They could not accept the complete relativity of everything to human nature and the impossibility of talking at all about things in themselves. It's curious how difficult it is to root out that mediaeval habit of thinking of "substances" of things existing apart from all relations, and yet really they have no possible meanings' " (Roger Fry, quoted by Virginia Woolf, *Roger Fry*).

"It will thus be seen that I desire to avoid dogmatising even in opposing dogmatism. It is of extreme importance to recognise not merely the relativity of taste, but what one may call its absoluteness in reference to a particular individual at a particular time. The taste, *as* taste, is a very real thing in everybody. . . . We shall trust ourselves, as we trust our own eyes and ears: while on the other hand, unless we wish to reduce our whole social life to chaos, we shall be willing to allow others to trust themselves" (E. E. Kellett, *Fashion in Literature*).

THE second part of this book is not concerned with that elucidatory type of criticism which endeavors to classify and explain works of art, but solely with judicial criticism, which tries to answer the questions: what is good or bad, better or worse? and what is a great work of art? Toward these questions it is possible for the art critic to adopt one of the following three attitudes. First, claiming that the functions of criticism are analysis and interpretation, he can ignore judicial criticism as unimportant. Second, he can make judgments of good and bad, better and worse, without understanding or stating the grounds for these judgments. Or third, he can attempt to comprehend the meaning of value judgments, and then make them. This procedure, which is the most worth while and most difficult of the three, requires a satisfactory theoretical basis.

The difficulties in achieving such a basis are both verbal and real. How puzzling and important semantic considerations are for art criticism I have tried to explain. These considerations, I now suggest, bear directly upon the following discussion, in which it is essential not to be confused by terminology. For example, the various possible uses of the words "objectivism," "subjectivism," and "relativism" might easily produce serious ambiguities. "Objectivism" will sometimes stand for a Platonic absolutism, as it does throughout this essay; again it will symbolize a concept similar to my interpretation of "relativism." Therefore some will choose to substitute in what follows the term "absolutism" for "objectivism" and the term "objectivism" for "relativism." This would be a verbal quibble.

My present problem, however, of the correct theoretical foundation for value judgments is not primarily semantic, but ontological. Granted, that is to say, that much of the current confusion in writings upon art comes from linguistic

mistakes of different sorts, nonetheless verbal predicaments should not obscure the reality of the problem. Questions of language should be disentangled from questions of fact. What I now hope to show is that a common type of objectivist criticism is inadmissible and perhaps harmful, that subjectivism is misleading and dangerous, and that only relativism will give sensible and significant meaning to value judgments. These critical theories are obviously special manifestations of more general value theories, the natures of which are, in what follows, much simplified. Yet even a shorthand account of three types of value theory may sufficiently elucidate the major problems in critical evaluation. Throughout the discussion, one general question to be remembered is this: what are the facts concerning value which everyone must recognize?

Before turning to the major discussion, however, it will be useful briefly to characterize a personage who is frequently referred to in the following pages: namely, the "expert" or "competent" or "judicious" critic. A relativist's conception of such a critic cannot be formulated without a certain vagueness since, as I shall later try to show, there will be different sorts of equally skilled critics not only for different periods but even within the same age. Even so, one may give some general notion of this hypothetical expert. I suggest that the more skillful the critic, the more completely will he possess and use the six following qualifications: (i) a natural sensitiveness to the aims of the artist and to the qualities of the works he is judging; (ii) a trained observation resulting from wide and varied experience with the kind of art he is considering; (iii) sufficient cultural (i.e., historical, religious, social, political, iconographic, and so forth) equipment to enable him to understand the objects of his criticism; (iv) a reflective power which will allow him to detect and hence to take into consideration personal eccentricities in his preferences, and by means of which he will analyze, weigh, and balance the effects which artistic creations make upon him; (v) a degree of nor-

mality, as opposed to eccentricity, which will make his range of experience sufficiently central to be available for participation by others; and (vi) a critical system which will present a satisfactory theoretical basis for artistic evaluations. To this last qualification of the expert critic we shall now give our attention.

I. OBJECTIVISM

Objectivism or absolutism typically holds that a definite amount of value resides intrinsically in the object in the sense that the value has ontological subsistence and is independent of any human relationship. It follows that the objectivist critic will believe in the existence of absolute, ultimate standards which lie outside or above human evaluations, will maintain that there is one and only one correct taste, and will strive for that objective rightness of judgment which, given his assumptions, must exist. To be sure, because of human finitude and fallibility, these ultimate standards can never be known and the absolute goal of correct judgment never be attained; yet expert critics will approximately agree in their evaluations even if their individual idiosyncrasies prevent them from liking and disliking in proportion as they approve or disapprove.

The objectivist, that is to say, naturally recognizes disagreement among competent critics, but he tends to explain this away by suggesting that while the personal, highly subjective likings of experts may vary, their more intellectually considered appraisals remain nearly constant. He thus finds support for his theory in the important critical distinction between *liking,* which is essentially a sensuous, immediate activity, and *approbation,* which is primarily rational and reflective—a distinction which some describe by contrasting the emotional spontaneity of the activity of "taste" with the intel-

lectual effort of the activity of "judgment." No doubt one would always wish to have liking and approbation coincide. No doubt, also, each of these activities stimulates the other since, as Professor Boas says: "There is a tendency on the part of all men to approve of what they like and to like what they have reason to approve of." [1] Nonetheless, the phenomenon of liking more than we approve and of approving more than we like is by no means uncommon. When Mr. Berenson, for example, actually rejoiced over the theft of the "Mona Lisa" from the Louvre, he was expressing a temporary distaste for a painting which he evaluates highly. Current opinions about Rubens, moreover, indicate that likings or tastes rate his art less highly than do reflective judgments. Or again, I at times intensely enjoy the most extravagant of baroque creations without wholly approving them, and I find it difficult, even while admiring Signorelli's art enormously, to like it more than moderately. To cite one further instance of the separation between taste and judgment: an expert literary critic recently remarked to me that, while he knew Dickens was a great writer, he found it nearly impossible to read him; in this case approbation and actual disliking went hand in hand.

The foregoing critical distinction, then, serves to bolster the objectivist belief in the approximate uniformity of reasoned critical appraisals. However, this supposed uniformity —which I shall later challenge in some detail—is in fact unessential to objectivism; for even were everyone to disagree as to the value of an object, the consistent objectivist must maintain that the amount of agreement is essentially irrelevant to his theory, since a specific value is ontologically there.

A typical illustration of objectivism occurs in the writing of W. T. Stace: "Even in questions of beauty a certain latitude is, of course, allowed to personal likes and dislikes. One man prefers Keats's 'Ode to the Nightingale' to the same poet's

1. George Boas, *A Primer for Critics*, p. 59. Boas makes a good deal of the distinction which is briefly considered here.

'Ode on a Grecian Urn.' Another critic prefers the latter poem to the former. Even here the tacit assumption is that one or the other must be right." [2] Analogous points of view are expressed in Matthew Arnold's references to the "real estimate," in Delacroix' search for the "true merit," and in Ruskin's belief in the "right judgment" and "true verdict" of a work of art.

Let us agree that the cornerstone for such objectivism is philosophical or ethical, in that every interpretation of value is inevitably affected by metaphysical and epistemological convictions. This view, to be sure, has been acutely questioned by writers who hold that esthetic doctrines should in no way depend upon solutions of metaphysical problems but should rather be discovered by the "scientific method." Any empirical nominalist would of course agree; yet this contention rests upon assumptions, which are also my assumptions, of the validity of the scientific method as opposed to the uncertain and relative character of metaphysical theory. But, even if esthetic experience can be scientifically analyzed and explained, *evaluation* of this experience cannot be independent of one's basic philosophical and ethical convictions. In Tolstoy's simple words: "The estimation of the value of art . . . depends on men's perception of the meaning of life; depends on what they hold to be the good and the evil of life." [3] Thus a philosophical belief in absolutes will impel a critic toward a thoroughgoing objectivism.[4]

2. *The Meaning of Beauty*, p. 207.

3. Leo Tolstoy, *What Is Art?* (The World's Classics), p. 127. Aylmer Maude, trans.

4. This sentence has been challenged, in correspondence, by Professor Philip Wheelwright who believes that "the hope of the world rests on those who do accept an absolute of some sort but do not accept dogmatic absolutism." It would be most interesting to have a full explanation of this sort of absolutism. It would be of great interest to know specifically and in detail how it differs from both the objectivism and relativism discussed in this essay. My belief is that the absolutes desired by Wheelwright are those which are only personally binding and which would be equally advocated by the

A further impetus in the same direction will perhaps be given by an unreasoned fear that the rejection of complete objectivism condemns one to a position devoid of all values: "If our belief in the validity of aesthetic judgments is not justified, if it is a mere illusion, then beauty ceases to be one of the values of life, and we lose out of our existence one of its positive ideals." [5] In his *Journal*, Delacroix gives a specific illustration of this fear that rejection of objectivism leads to subjectivism:

One would be embarrassed to say in what respect Mozart can be inferior to Cimarosa, according to the idea of him that I have here. Perhaps something personal in my organization causes me to incline in the direction to which I do incline; yet an argument such as that would be the destruction of every idea of taste and of the really beautiful; every personal sentiment would be the measure of the beautiful and of taste.[6]

Since critical relativism, as we shall later see, thoroughly disposes of this false dilemma, we may dismiss the apparent difficulty at this point by agreeing with John Dewey that "the idea that unless standards and rules [and hence specific judgments too] are eternal and immutable they are not rules and criteria at all is childish." [7]

Since the objectivist critic clearly cannot rest his case upon presuppositions of the foregoing sort, he will seek, in support

relativist theory later to be discussed. It is important to notice that, if my explanation of this problem is correct, a verbal snare is at the root of the ambiguity.

In his persuasive defense of critical relativism, Professor F. A. Pottle remarks that "relativism in physics and in theory of poetry does not imply as a logical consequence relativism in matters of faith and morals" (*The Idiom of Poetry* [Ithaca, 1941], p. 32). I believe, however, that belief in both critical relativism and moral absolutism, if in no way illogical, is, nonetheless, unusual.

5. Stace, *op. cit.*, pp. 207–208.

6. *The Journal of Eugene Delacroix*, p. 213.

7. "The New Failure of Nerve," *The Partisan Review*, January–February, 1943, p. 37.

of his view, positive, concrete evidence which will usually assume one or more of three main forms. First, as suggested above, the critic will claim, citing perhaps Phidias and Raphael as examples, that throughout the centuries the best minds have agreed upon the value of works of art. Or second, he will argue that the use of words like "beauty," "esthetic quality," and "artistic quality" to characterize the most diverse objects implies the existence of a common and intrinsically valuable property. Or third, he will assert that an inherent and permanent value has been given to art objects by the conscious artistic aims of their creators. I shall now consider these three arguments.

(A) Uniformity in Expert Value Judgments?

If uniformity of expert critical opinion exists anywhere, one would expect to find it within a small time span; yet what is more common today than divergent value judgments? Distinguished art historians and critics frequently hold diverse and, occasionally, even opposite opinions concerning both contemporary art and that of the past. Now when A in a college art department rates Picasso's "Guernica" highly and considers the Metropolitan "Kouros" artistically insignificant while B holds the reverse opinions, one or the other, if objectivism is true, is fortunate that the theory is empirically unverifiable. Or, how can objectivism reasonably account for the contradictory judgments of eminent modern critics upon the art of Millet? How is it that Wilenski and Fry in their books on French painting entirely ignore this art while Mather considers it the "most significant work of the century"? Or again, what could be more opposed than two currently widespread views concerning baroque art: the one regarding it as the degeneration and disruption, the other regarding it as the culmination and flowering of the classical Renaissance style? Extreme disagreement occurs among the best writers, moreover, in all critical fields. Thus in a criticism of *For Whom*

the Bell Tolls, Dwight Macdonald remarks: "I think the novel is a failure for precisely the reason that many critics seem to like it most: because of its rejection of political consciousness." [8] Such occurrences, to be sure, may be partially explained away by the distinction discussed above between liking and approbation. Through the understanding, one may come to realize that a liking is partially motivated by personal eccentricities irrelevant to artistic appraisal. In that event, one will *modify* the appraisal. Even so, opposed approbations will remain, since they are founded upon basically different attitudes toward art which are seldom changed merely by increased understanding. In short: liking, understanding, and approbation are three different aspects of participation in a point of view.

Do we not find, moreover, that all famous critics have made sober evaluations which are astonishingly unorthodox? This subject could be properly examined only in a volume which might be interestingly filled with examples from the finest critical writings of all periods. For my purposes, a few typical instances will suffice. A characteristic eighteenth century comparative judgment between classical and medieval art is expressed by Addison in these terms: " 'Let any one reflect on the disposition of mind in which he finds himself at his first entrance into the Pantheon at Rome . . . and consider how little in proportion he is affected with the inside of a Gothic cathedral, though it be five times larger than the other,' the reason being 'the greatness of the manner in the one, and the meanness in the other.' " [9] For Horace Walpole, " 'All the qualities of a perfect Painter never met but in Raphael, Guido and Annibal Carracci.' " [10] Sir Joshua Reynolds not

8. *The Partisan Review,* January–February, 1941, p. 25. Cf. with the following remark in Ambroise Vollard's *Renoir* (New York, 1925), p. 47: "The very qualities in Manet that attracted Daumier, repelled Courbet."

9. George Saintsbury, *A History of English Criticism* (New York, 1911), p. 177.

10. John Steegmann, *The Rule of Taste* (London, 1936), p. 102.

only highly praises an artist like Tibaldi, who is almost unknown at the present time, but also condemns the art of Bernini (which today is glorified by some, repudiated by others) , refers to the "vulgar eagerness" of the "Discobolus," and briefly dismisses as "old painters" Mantegna, Perugino, and Dürer. Turning to the nineteenth century, we find Hazlitt remarking, in one place, that Murillo's "Beggar Boys" at Dulwich "is the triumph of this collection, and almost of painting," and in another, that while Michelangelo's forms have "an intellectual character about them and a greatness of gusto . . . his faces on the other hand have a drossy and material one." [11] Delacroix ranks Lesueur and Lebrun above Poussin, Ruysdael and Ostade above Watteau; and Taine condemns Fra Angelico, Dürer, and medieval art in general. Only yesterday Roger Fry, in *Last Lectures,* launched an almost wholesale attack upon the esthetic value[12] of Greek sculpture, while Lionello Venturi remarked that "in Italy, there was a steady production of great art from the 13th to the 20th century." [13] Remarkable contemporary evaluations are equally common in expert literary criticism. Thus Yvor Winters places "Jones Very above Emerson, Bridges and Sturge Moore above Yeats, Williams above Pound and Eliot, and Edith Wharton above Henry James." [14] But the most astonishing judgment with which I am familiar comes from the poet-critic W. H. Auden: "If I am to trust a reviewer's judgment upon a book I have not read, I want to know among other things his philosophical

11. William Hazlitt, *Essays on the Fine Arts* (London, 1873), pp. 397, 313.

12. The adjectives "esthetic" and "artistic" are used throughout this essay in a fairly free and unspecific sense. At the same time, *some* distinction in meaning between the two words is intended. By "esthetic" I refer to that aspect of experience which may be roughly characterized as disinterested contemplation or as perception of data for their own sake. By "artistic" I refer very generally to aspects of experience or to properties of objects which have been associated with the fine arts. While the definitions of the terms necessarily overlap, they are by no means identical. A similar distinction would hold between "beauty" and "art."

13. *Art Criticism Now,* p. 38.

14. R. P. Blackmur, *The Expense of Greatness* (New York, 1940), p. 168.

beliefs. If I find, for instance, that he believes in automatic progress I shall no more trust him than I would trust a philosopher who liked Brahms or Shelley." [15]

If one reflects, furthermore, upon competent critical opinions over a period of centuries, does the relative uniformity of evaluation accorded Phidias and Raphael seem more impressive than the violent fluctuations in the fate of Botticelli, Michelangelo, El Greco, Rembrandt, Velasquez? [16] Even the very high praise, indeed, which most judicious critics have accorded Raphael has been recently questioned. For example, when comparing the expression of sentiment in the painting of Raphael and of Fra Bartolommeo, Roger Fry decides that, "being much more frankly and vulgarly sentimental, Raphael tends to be more trivial and, the word is hardly too strong, on occasions, silly." [17] Or again, contrast the unqualified praise of Vasari and his contemporaries with the present low estimate of Raphael's "Entombment." This striking change in the evaluation of Raphael's art is summed up by the following no doubt exaggerated statement: "Raphael was for three centuries the Prince of Painters. Then he became, for many, the Prince of Potboilers." [18]

If one considers not merely the *rating* of artists and monuments but the varied kinds of evaluations they have received, it soon becomes evident that critics of different periods praise a given artist and his works for very different reasons. In a study of the criticism of the "Mona Lisa," [19] Boas describes and explains the striking contrast between the judgment of Vasari and the very different judgments of Gautier and Pater:

15. "Criticism in a Mass Society," *The Intent of the Critic*, pp. 142–143.

16. It does not seem to me necessary to prove the existence of these fluctuations. The history of criticism plainly shows that there have been periods when many artists who are today considered great were either ignored or disparaged.

17. *Transformations* (New York, 1926), p. 84.

18. Leo Stein, *The A–B–C of Aesthetics* (New York, 1927), p. 29.

19. "The Mona Lisa in the History of Taste," *Journal of The History of Ideas*, April, 1940.

whereas the late Renaissance with its notorious interest in scientific investigation praises Leonardo's technical skill and fidelity to nature, the nineteenth century with its new conception of woman praises the mysterious and enigmatic character of Leonardo's interpretation. In the case of Tintoretto, whose general critical *rating* through the centuries is notable for its consistency rather than for its fluctuation, some critics (e.g., Ruskin) value his art for its dramatic and religious expressiveness, whereas other critics (e.g., Pittaluga) challenge the artistic importance of this content and insist that Tintoretto should rather be praised for his original and remarkable use of light.[20] This obvious yet frequently neglected fact of the existence of diverse kinds of appraisals may be further illustrated by these remarks about Milton:

You cannot miss his grandeur. And yet it is clear that hardly two people can read him in the same way. He makes one appeal to the ignorant, another to the fairly well-read, another to the profoundly learned: one to the student of Homer, another to the Dante-enthusiast, another to the "correct" Frenchman who is steeped in Racine: yet another, may I add, to Mr. T. S. Eliot? For even Mr. Eliot, amid all his depreciation of Milton, reveals that he is somehow conscious of the poet's greatness.[21]

In extreme cases of diverse judgments, objects once valued *chiefly* as utilitarian productions have become, for later cultures, solely esthetic objects—museum pieces. Examples would be African spoons and fetishes or the majority of Italian Renaissance drawings. Even if it is true that the spoons and fetishes were created for their beauty as much as for their efficiency, esthetic considerations were surely once less domi-

20. Mary Pittaluga, *Il Tintoretto* (Bologna, 1925). On pages 109–167 the author gives a most interesting historical account of the criticism of Tintoretto.

21. E. E. Kellett, *Fashion in Literature* (London, 1931), pp. 55–56.

nant than they are today. In the case of the drawings, the facts that, during the Renaissance, they were considered mere working materials, and were generally neglected and often destroyed, indicate a striking contrast to our contemporary evaluations. "Until well into the sixteenth century," says Bernard Berenson, "drawings seem to have had no value on their own account, and were passed around from assistant to assistant, student to student, until they were used up." [22] This testimony indicates that, contrary to the views of some writers, contrasting appraisals do not apply solely to artistic content.[23] Thus, while it is probably true that changes in evaluation are more marked in the case of content than of form, I find no evidence for believing, with Mr. Herbert Read, that whereas elements of content are "temporal," elements of form are "universal."

Comparable illustrations of diverse evaluations might be supplied indefinitely from all fields of knowledge. Particularly enlightening is the field of anthropology, which offers abundant evidence for the dependence of evaluations upon custom and environment by showing that the beliefs about death, sex, power, beauty, et cetera, of various cultures are often the reverse of ours.[24] And with regard to ethics, Spengler reaches this conclusion: " 'Every civilization has its own ethical standard; and the validity of this standard begins and ends with that civilization itself. There is no such thing as a universal human ethic.' " [25]

Such diversity in kinds of evaluation is important for the following reasons: first, it presents cogent empirical evidence against the notion of uniformity in expert value judgments; second, it actually *explains* the fact that certain works of art

22. *The Drawings of the Florentine Painters*, I, xi.
23. "Content" and "form" are defined on pp. 79–80.
24. Fascinating material on this subject is presented by Ruth Benedict, *Patterns of Culture* (Boston, 1934).
25. A. J. Toynbee, *A Study of History* (2d ed. London, 1935), III, 382.

are highly praised by very different persons and by very different cultures—a fact which would hardly be explicable were objectivism true; and third, it points to a basic variety in the attitudes or points of view which determine critical appraisals.[26]

Now the moment one realizes the inevitability of this variety—a variety which is of course inevitable because of the diversity of cultures and of individuals and which effectively refutes the notion of a static esthetic sensibility—the "whirligig of taste" and of judgment which we have been considering becomes comprehensible and enlightening. As a result of our modern environment, our ideas about the nature and function of art are unlike those of the past; consequently we today see the art of former epochs with eyes differently focused from those which first saw that art. Plato, for example, believing in the identity of the good and the beautiful, seems always to be speaking of moral beauty; and while this identity may be "axiomatic, absolute, irreducible" for such a humanist critic as Middleton Murry, it is rather the separation of the two which is emphasized in esthetic theories of the present day. To illustrate further this contrast between the Greek attitude toward art and our own, we may observe that: (i) no evidence appears before the fourth century B.C. of the existence of esthetic consciousness as we now know it; (ii) Greek architecture was so much a part of Greek religion that the highest praise given Phidias by his contemporaries was that he had enriched the religion of the state; (iii) the only aspects of art objects besides moral effectiveness and usefulness which were praised by the fifth century B.C. were size, costliness, and fidelity to nature.[27]

26. Any discussion of the principles of causation which determine this variety in attitudes would lead far beyond the limits of this book, for these principles are an infinite complex of philosophical, psychological, physiological, sociological, economic, historical, and artistic forces.

27. For this and other interesting material concerning the Greek attitude

Similarly the references to art and beauty in the Middle Ages reveal an artistic and esthetic approach quite unlike ours: "What sort of admiration for the art of their time was felt by the men of the fifteenth century? Speaking generally, we may assert that two things impressed them especially: first, the dignity and sanctity of the subject; next, the astonishing mastery, the perfectly natural rendering of all the details." [28] Such facts surely prove that classical and medieval monuments cannot have the same signification for us that they had for their own civilizations; we cannot possibly experience and hence cannot value them in the same manner.

Even in the Renaissance—a period much closer to our own in all ways—the best writers base their criticism upon an esthetic quite unacceptable to most of us. Alberti and Leonardo, the leading theorists of the fifteenth century, stress the importance in painting of a literal imitation of nature;[29] and from the middle of the sixteenth until the middle of the eighteenth century, critics in France and in Italy, profoundly influenced by Aristotle's *Poetics* and by Horace's *Ars poetica,* "virtually identified the art of painting with the art of poetry" and contended, as the core of their new as of ancient theory, "that painting like poetry fulfils its highest function in a representative imitation of human life, not in its average but in its superior forms." [30] This latter notion, to be sure, now seems relatively sensible by comparison with other codified, legislative principles of the seventeenth century such as the

toward art, see F. P. Chambers, *The History of Taste* (New York, 1932), Appendix: "The Cycle of Antiquity."

28. J. Huizinga, *The Waning of the Middle Ages* (London, 1927), p. 243. In this connection, see A. K. Coomaraswamy, "Mediaeval Aesthetic," *The Art Bulletin,* March, 1935, and March, 1938.

29. See Anthony Blunt, *Artistic Theory in Italy* (Oxford, 1940), chaps. i and ii.

30. R. W. Lee, "The Humanistic Theory of Painting," *The Art Bulletin,* December, 1940, p. 201.

unquestioned rule that in painting drawing is far more important than color.

Or if our contemporary ideas as to the fundamentals of art and beauty are compared with those of the nineteenth century, how can one expect anything other than divergent critical estimates? Are we to conclude that Ruskin was wrong *absolutely* in holding that the chief functions of Fine Art are to influence the religious sentiments of men, to perfect their ethical state, and to render them material service? Finally, if because of basically diverse artistic attitudes our most characteristic standards and judgments inevitably differ from those of past centuries in western culture, shall we not expect to find even greater dissimilarity between our standards and judgments and those of Eastern critics of all periods? If so, it is not surprising, though it is interesting and significant, that there is no exact equivalence in Chinese art criticism for any such familiar western concepts as unity, proportion, scale, and movement.

Professor T. M. Greene cites an instructive example of shifting attitudes: "The Dorian mode, which to the Greek ear was strong and virile, is, to our ear, a minor scale with an entirely different set of emotive-conative associations, somewhat as white is the expressive symbol of death and mourning for the Chinese and Japanese, as black is for us." [31] This admission that something may have opposed yet apparently legitimate values for different cultures is fundamentally destructive of a consistent objectivism, for if a quality recognized by one period as a certain kind of value becomes for another period an entirely different value, how can the value reasonably be considered to have ontological subsistence in

31. *The Arts and the Art of Criticism*, p. 332. I take this opportunity to remark that my various adverse criticisms of Mr. Greene's book, even if justified, in no essential way invalidate the main portion of his arguments and analyses.

the object? The moment, that is, that one accepts two differ-
ent appraisals as correct, the objectivist position collapses; for
either the value is *a priori* in the object, in which case either
the Greek ear or ours is incapable of finding and appreciating
it, or, according to our definition, it cannot be objective.

Greene's analysis of the implications of his comment upon
the Dorian mode is instructive:

This does *not* condemn us, however, to a pure subjectivism or
relativism, nor does it preclude the possibility of genuine com-
munication in this medium. For musical conventions and asso-
ciations, like those of a verbal language, are sufficiently stable
and enjoy a sufficiently wide acceptance in any period and culture
to permit of communicatory exploitation.[32]

Now since a relativist, like myself, would assert nothing else,
and since Greene defines his position as objectivist, the ques-
tion naturally arises: does Greene's objectivism differ in name
only from the relativism I shall later defend?

The question is puzzling and important; the answer is
sometimes "yes," sometimes "no." The ambiguity results, I
believe, from Greene's failure to give an *exact* meaning to the
word "objectivity" and hold to it. On occasion, he leans to-
ward the absolute objectivity we have been discussing. For
example: "Our evaluations are correct or incorrect according
as we ascribe or fail to ascribe to such objects the values which
they actually possess." [33] Further evidence that his position is
completely objective is his belief in absolutes as "a point of
reference" and a consequent conviction that human finitude
is the cause preventing omniscience of judgment in critical
matters. These notions of absolutes and omniscience, that is
to say, imply the existence (in the mind of God?) of an Ideal

32. *Ibid.*, p. 333.
33. *Ibid.*, p. 463.

in relation to which everything should be judged. On the other hand, we find evidence in Greene's work against absolutism. He is too intelligent a critic not to realize the implications in his remark concerning the Dorian mode and the resulting impossibility of achieving "complete objectivity" in any type of critical appraisal. All that can be hoped for, we learn from one passage, is "relative objectivity," a concept which may roughly correspond to the relativism later to be discussed, but which, unfortunately, is nowhere exactly defined or explained. Thus Greene's position is essentially ambiguous in that it shifts between an absolute and a relative type of objectivity. One receives the general impression that his critical empiricism does not harmonize with his apparent inclination toward philosophic absolutism. Therefore in regard to value theory and value judgments Greene appears to straddle the only two possible alternatives: namely, either that value is inherent *a priori* as a real property of the object or it is not. He seems to change from one position to the other; but he cannot both have his cake and eat it.

This discussion of the first concrete objectivist argument has shown, first, that empirical evidence indicates an *absence* of that approximately universal agreement among good critical opinions claimed by objectivists in support of their theory; and second, that it is sometimes impossible to tell whether differences between objectivism and relativism are real or verbal, since some writers seem reluctant to give precise meanings to their key terms.

(B) *An Intrinsic Common Quale in Beauty and Esthetic Quality?*

Linguistic dodges also pervade the argument that the use of words like "beauty" or "esthetic quality" to characterize diverse things implies the existence of an intrinsic common value. Sir Joshua puts it as follows: "But as the idea of beauty

is of necessity but one, so there can be but one great mode of painting." [34] Yet if various kinds of objects are valued for all sorts of reasons, what can they, or do they, have in common? Such a sensible answer as "unity" in fact helps little, since there are as many sorts of unity as there are types of art objects. Another suggested reply, "richness and purity," is not only vague but self-contradictory, for an art which stresses one of these qualities will tend to neglect the other. When we search further for explanations of the phrase "esthetic quality," we usually find only such tautologies, or examples of what is called in logic the "vicious circle in the definition," as "aesthetic quality is the lowest common denominator of all aesthetic objects," or "*anything* may be said to possess 'aesthetic quality' which evokes an aesthetically re-creative response in a sensitive person." [35]

Indeed the objectivist, if pressed for a meaning, is forced to consider "beauty," "artistic quality," and "esthetic quality" as unanalyzable ultimates which are variously described as unique, irreducible, ineffable, indefinable. Thus Greene states: "Like color and sound, beauty is an irreducible, unique, and ineffable quality." [36] This contention is held not only by all absolutists but even by such a relativist, or contextualist as he calls himself, as S. C. Pepper, who entitles a book *Aesthetic Quality*, a phrase which turns out to represent an ultimate notion which, according to Pepper, cannot be defined but only emotionally intuited. An explanatory passage from Greene's book will make the objectivist position upon this point more explicit:

Like life, consciousness, rationality, and moral goodness, aesthetic quality and its variants are ultimate and unique. As such, they

34. Reynolds, *Discourses*, III, p. 64. Roger Fry, ed.
35. Greene, *op. cit.*, pp. 6, 5.
36. "Beauty and the Cognitive Significance of Art," *Journal of Philosophy*, July, 1938, p. 365.

cannot even be defined, since definition always involves the description of the defined objects in terms of something else. . . . Whoever, through ignorance or perversity, denies them altogether automatically excludes himself from the universes of discourse which presuppose their empirical reality, for only if this reality is admitted can their nature and import even be discussed.[37]

Is it not interesting that the objectivist's claim here relies solely upon intuitive certainty?

This large problem of the status of unanalyzable ultimates cannot be argued here (and it will never be definitively settled, because any solution will of course depend upon one's basic convictions concerning cognition and reality), but the questioning reader is urged to investigate recent attacks upon the foregoing kind of metaphysic which seems to the writer a chief source of intellectual confusion in many fields of knowledge. In contrast to the last quotation, consider the following:

We can say that we are dealing with a legitimate abstraction if it is possible to interpret the sentence in which it occurs into another sentence in which that abstraction no longer appears as a term. If it is impossible to do this, then we are dealing with a metaphysical white elephant, an expression which cannot be true or false because it is scientifically meaningless.[38]

Or, as Grudin puts it, "A man who does not know 'what a thing means,' does not 'know that thing' "; and he is thereby

37. *The Arts and the Art of Criticism,* pp. 14, 15.
38. Sidney Hook, *Reason, Social Myths, and Democracy* (New York, 1940), p. 17. If anyone maintains that I am confusing "abstractions" with "intuited qualities," I should reply that the unanalyzable ultimates or unique intuited qualities referred to by Greene may fairly be considered instances of the "indefinable," "illegitimate," and "vicious" abstractions discussed by Hook. Reasoned evidence for disbelieving in these abstractions is also given by J. R. Reid in his book, *A Theory of Value:* in chap. ii he punctures Moore's famous arguments in *Principia Ethica,* and in chap. v he reveals as an absurdity the notion which considers "personality" an indefinable ultimate.

guilty of the "fallacy of unoriented being" which "consists in
the belief that certain 'primary' affairs *merely are.*" [39] Further-
more, the entire discussion in the preceding essay of volitional
and real definitions affords considerable linguistic evidence
for repudiating the unanalyzable, indefinable ultimates in
question.

Now *can* "esthetic quality," for example, be explained
more satisfactorily than as an unanalyzable ultimate? I be-
lieve that it can be, and I suggest that more comprehensible
meanings for the slippery phrase may take at least the follow-
ing three forms which may be designated "emotive," "referen-
tial," and "emotive-referential." [40] The emotive use of "es-
thetic quality" first and foremost *expresses* an attitude of
pleasure and approval. No specific property of the object is
consciously present to one's attention, yet the emotional effect
of the object upon the observer is registered. It is usually this
sort of meaning which the objectivist will incorrectly inter-
pret as an unanalyzable ultimate. In the second place, "es-
thetic quality" may symbolically refer to any one of a number
of relatively objective[41] properties in a work of art such as
compositional patterns or linear rhythms. Thus one might
speak of plastic form as the chief artistic quality of a painting

39. *A Primer of Aesthetics*, pp. 178, 54.
40. A discussion of the term "beauty" comparable to the following analysis
occurs on pp. 45–48.
41. "Relatively objective" is meant to convey the idea that the properties
are objective in that they do not *belong to* the self, yet are relative in that
they are *dependent upon* individual organisms. This important characteriza-
tion of works of art and their properties as at once "phenomenally objective,
functionally subjective" (or relative) has been admirably explained by Pro-
fessor K. Koffka, "Problems in the Psychology of Art," *Bryn Mawr Notes and
Monographs*, IX (1940). Works of art or their properties would be considered
completely or functionally objective only by the naïve realist who equates
and so confuses what we see with what the physicist calls the real nature of
objects (i.e., atoms, electrons, et cetera). Actually, of course, "the physical real
objects that we call art-objects are such only by virtue of their effect on a
spectator. As a physical thing, an art-object is but a set of conditions which
will produce a phenomenal art-object in a spectator" (Koffka, *ibid.*, p. 259).

by Giotto. Most frequently, however, the phrase both ex-
presses the emotional response of the observer and refers to
the excellence of one or more relatively objective properties
which are usually unspecified, but which might be technical,
formal, expressive, and the like. The precise meaning of this
convenient and prevalent "emotive-referential" sense of "es-
thetic quality" is particularly difficult to determine, since the
accent upon the emotive effect or upon the "objective" refer-
ence will vary indefinitely from use to use. At one extreme,
the term may tend to approximate the purely emotive mean-
ing; at the other, it may be chiefly a shorthand reference for
certain valued properties.

The lesson to be learned from all such interpretations of
this and similar terms is that there is no *a priori* reason to pre-
suppose the existence of a common, intrinsic, and inexplica-
ble *quale* connoted by the terms. Unless, then, one assumes
a naïvely objective attitude toward beauty and esthetic qual-
ity, the situation regarding such a *quale* is analogous to a simi-
lar situation regarding the causes of death: "Of all the things
which cause death we can say if we like that they are lethal,
but we are no longer tempted to think that we are saying any-
thing more about them than that death did occur in connec-
tion with them." [42]

Contrast this empirically clear and profoundly revealing
comment with the following characteristic objectivist sample:

The great merit of Croce's theory is that, more clearly than any
writer since Plato, he emphasizes the unity of beauty. And his
strongest argument is his appeal to the history of aesthetics, his
contention that all theories opposed to his own have only gained
plausibility by admitting two or more realms of beauty, to but
one of which their explanations properly apply. Still, it may be
possible to accept his Platonic assertion that beauty is a real

42. Ogden, Richards, and Wood, *The Foundations of Aesthetics*, p. 58. Cf.
n. 74 of Part I.

universal and yet to doubt whether he has answered the Platonic question—What is that which by its presence in all beautiful things renders them beautiful? [43]

An analogous view is expressed by Lionello Venturi's remark that "calling form both *plastic* and *associative* shows lack of serious thought. The conjunction *and* is not looked on favourably in philosophy. Serious thought always tries to understand what can make two things one." [44] Thus the metaphysical chase for a non-existent entity still continues.

Sometimes, in order to give an air of empirical or perhaps even scientific plausibility to their ultimates, the objectivists will try to strengthen their argument by analogically claiming for unanalyzable abstractions the same kind and degree of objectivity—if not more!—that can be claimed for such secondary qualities as sound and color. Thus Greene remarks of artistic quality: "As a simple and ultimate quality it eludes analysis as inevitably as do sound and color";[45] and T. S. Moore states: "Beauty is beauty as good is good, or yellow, yellow." [46]

But the analogy is misleading, partly because the transaction between subject and object is far more direct and simple, less intricate and subtle in the case of a pure sound or color experience than in an artistic one, and partly because anyone advocating this analogy should be able to point to a distinct *quale* characterizing artistic quality, esthetic quality, or beauty, which could be reasonably compared with that of a color or sound. The analogy would hold only if beauty, artistic quality, and esthetic quality were, like color and sound,

43. E. F. Carritt, *Philosophies of Beauty* (London, 1931), xxvii.
44. *Art Criticism Now*, p. 43.
45. *The Arts and the Art of Criticism*, p. 389. This argument, which may derive from G. E. Moore, was effectively anticipated by R. B. Perry, *General Theory of Value* (New York, 1926), and by J. R. Reid, *op. cit.*
46. *Albert Durer*, p. 321.

empirical qualities which could be unambiguously pointed to; but, *pace* great names, no such situation confronts us. In short, through erring metaphysics and a misleading analogy, absolutists attempt to beguile one into believing that values are ontologically intrinsic.

(C) The Intention of the Artist

Let us turn to their third main argument: it is sometimes held—notably by Crocean theorists—that the intrinsic value of works of art depends upon the purpose or intention of the artist, who, by means of an object, is attempting to communicate something to us. For example, Wilenski in *The Modern Movement in Art* dogmatically "submits" that there is an intrinsic and constant value in art objects which is entirely derived from the attitudes, motives, and procedures of the men who made them. Now, granting that value may legitimately be defined in terms of the artist's intention and that, when so defined, it becomes, as we shall later see, a useful standard for appraisals, the emphasis upon the *constant* character of the value is open to objections of various sorts.

In the first place, how can the intention of the artist and its success be precisely determined? The sole test for Wilenski is whether the work "has been honestly and correctly passed as right by the artist himself in his capacity of spectator." [47] But do not the words "honestly" and "correctly" beg the question? How can one know whether the artist is honest or dishonest, correct or incompetent in his judgment? Suppose that, as T. S. Eliot says, "There may be much more in a poem than the author was aware of";[48] or that, to quote John Dewey, "It is absurd to ask what an artist 'really' meant by his product; he

47. R. H. Wilenski, *The Modern Movement in Art* (new ed. London, 1935), p. 188.
48. "The Music of Poetry," *The Partisan Review*, November–December, 1942, p. 457.

himself would find different meanings in it at different days and hours and in different stages of his own development." [49] Or, to quote an even more extreme statement of this point of view by the painter-critic Roger Fry: " 'I'm certain that the only meanings that are worth anything in a work of art are those that the artist himself knows nothing about.' " [50] Moreover, consider as a challenge to the justice of regarding the value of the artist's appraisals as intrinsic and constant the likelihood that the points of view, hence the evaluations, of the artist and of the critic will diverge: the likelihood, as M. Focillon expresses it, that "the creator of a work of art regards his work . . . from a standpoint wholly opposite to that taken by the critic, and should he chance to use the same language in speaking of it, he does so in quite an opposite sense." [51] Besides, suppose that the artist has left no record of his purpose or the success of its fulfillment?

All such practical considerations will not, of course, disturb the objectivist. But reconsider in this connection the crucial reflections that the artist's intention is conditioned by and relative to his culture, standards, and environment and that "our estimate of those 'intentions' is inevitably influenced by our own attitude which in turn depends on our individual experiences as well as on our historical situation." [52] Thus the evaluation of the intention or of the properties given an object by this intention always bears a relation to someone: the artist or the critic. That, indeed, the only intelligible meaning

49. *Art as Experience,* pp. 108–109.

50. Virginia Woolf, *Roger Fry* (New York, 1940), pp. 240–241.

51. Henri Focillon, *The Life of Forms in Art,* p. 1. Certain of Picasso's statements about works of art lend important confirmation to the views of Focillon and Dewey cited in this paragraph. See A. H. Barr, Jr., ed., *Picasso: Forty Years of His Art* (The Museum of Modern Art, New York, 1939), pp. 15, 19.

52. Erwin Panofsky, "The History of Art as a Humanistic Discipline," *The Meaning of the Humanities* (Princeton, 1938), p. 105.

of the theory we are considering supports a relativist, not an objectivist approach, seems granted by Wilenski himself in his preference eight years later for the term "artist-acquired" instead of "intrinsic" as an epithet descriptive of artistic values.

Further, if values are to mean what the artist wishes to communicate, in what terms can we discuss the esthetic values of nature? The reply of Professor Greene and others that whereas the values of art objects are objective (the exact meaning of "objective" in this context is unimportant), those of nature are subjective, would rarely occur to anyone but a metaphysician. According to this theory, the esthetic experience of nature is creative rather than re-creative in that man projects into nature his own emotions and impulses, ascribing to nature "the expressive forms in terms of which he aesthetically apprehends it." [53] Thus things not man-made, it is urged, lack the objective values of artistic creations and require, therefore, a diametrically opposed philosophical analysis. Coleridge neatly expresses this view in his remark that "the venison is agreeable because it gives pleasure; while the Apollo Belvedere is not beautiful because it pleases, but it pleases us because it is beautiful." [54] But as Shawcross rightly explains, Coleridge reaches this conclusion by the unjustifiable expedient of interpreting the "agreeable" or the "beautiful" subjectively in one breath, objectively in the next; and he adds: "To the assertion 'the Apollo pleases us because it is beautiful' an objector might reasonably reply 'yes; and the venison pleases us because it is tasty.'" [55] In short: is not this sharp distinction between two obviously connected sorts of experience unreal and fantastic? Does it not suggest that the interpretation of both is incorrect?

53. Greene, *The Arts and the Art of Criticism*, p. 10.
54. *Biographia Literaria* (London, 1939), II, 224. J. Shawcross, ed.
55. *Ibid.*, p. 308.

(D) Two Analogical Arguments

There are, of course, minor arguments in defense of objectivism. A recent one, which is used in support of a belief approximating absolutism, depends upon the following analogy between Greene's interpretation of artistic perfection and Aristotle's interpretation of moral value. Now the mean in ethics for Aristotle is not one which is " 'one and the same for all men,' but rather the 'intermediate relative to us' "; or again, "All moral decisions, since they are 'relative to us,' *are* particular decisions." [56] However, "Aristotle is careful to point out that there is actually *one and only one* completely virtuous course of action for any specific individual in any concrete situation, and this course of action *is* objectively valid and morally compelling." [57] On the basis of this Aristotelian position, what analogy does Greene draw? Briefly, that just as there is a single right course of action for an individual in any one situation, so is there a "specific artistic form" which "is absolutely right for a specific work of art." But would not a more exact and telling analogy suggest that just as moral values are different for different moral agents, so artistic values are relative to and dependent upon different types of observers? On the same page, Greene explains his point further: "What is relative to a unique frame of reference need not, on that account, be 'merely' relative. It can be *absolutely* valid *in that specific context.* If Q is valid for S^1 and R for S^2, Q and R are *not* absolutely valid *without qualification;* but Q *is* none the less absolutely valid *for* S^1, and R *for* S^2." Whereas Greene would have Q and R stand for different artistic "forms" and S^1 and S^2 for different works of art, I should suggest that S^1 and S^2 might be different types of individuals and Q and R value judgments. My aim is not to press

56. Greene, *op. cit.,* pp. 393, 394.
57. *Ibid.,* p. 396.

this point but rather to show how readily such analogies can be turned against their originator.

A second analogical argument endeavors to defend objectivism by comparing artistic values with certain aspects of scientific truths. Some writers hold, for instance, that far more radical changes have occurred in the development of science than in the fluctuation of taste and that, consequently, artistic values are comparatively stable—a contention which the foregoing evidence against objectivism renders highly dubious and which in any case seems unimportant or even irrelevant when one contrasts the current unanimity of scientific opinion with the current diversity of artistic evaluations. More telling is the attempt, which was made in correspondence with me by Professor Andrew Bongiorno of Oberlin College, to refute the argument that changing judgments of values prove that values have no objective subsistence by pointing out that changing views of the nature of the physical world do not prove that physical phenomena change with men's notions of them. But is it not evident that the only reasonable analogy to be drawn from this comparison is that, just as changing views of the nature of the physical world do not prove that physical phenomena change with men's notions of them, so changing views of works of art do not prove that these works change *physically* with men's notions of them? The very different analogy which Bongiorno makes between artistic values and physical phenomena is unreasonable because it *assumes*, in a most unwarranted way, that artistic values and physical phenomena are, to an equal degree, intrinsic objective *quales*. All available empirical evidence seems to show, on the contrary, that artistic values, unlike physical phenomena, are largely dependent upon an experiencing subject; to use Koffka's terminology, they are "functionally subjective." Bongiorno's argument further runs that just as there are scientific facts which are now unknown but which may become known in the future, likewise there are inherent values in art objects

which are awaiting discovery. But again this analogy, like so many others, is misleading: first, because it, too, wrongly assumes that values have ontological subsistence and are therefore comparable to physical phenomena; second, because the two fields of investigation are disparate *even if* one misguidedly grants the existence of objectively intrinsic values. For whereas scientific truths are at once tentative, testable, and public, objective values are supposedly eternal, certainly unverifiable, and preëminently personal. Therefore any such comparison as that, let us say, between the nature of a scientist's indefinite yet ascertainable knowledge of the distance from New York to Dakar and an expert critic's re-evaluation of a Rembrandt portrait proves nothing whatever.

Because the several specific contentions in favor of objectivism can be refuted as either unsound or unintelligible or both, and because of "the complete impossibility of finding any arguments to prove that this or that has intrinsic value," [58] the theory must be entirely rejected. This conclusion many will be reluctant to accept, partly from fear of commitment to complete esthetic libertinism (a fear which relativism will show to be absurd), partly from a longing for certainty combined with a belief that it is somehow worthy and noble to strive for an ideal, however vague and unattainable. Now while the relativist art critic will deplore, he obviously cannot alter a longing for certainty, for "though the absolute is surely a bird whose tail we shall never salt, no one knows whether we shall ever stop pursuing it." [59] He can suggest, however, that the goal of objectivity may be not so much noble as esthetically and psychologically dangerous.[60] The problem cannot be argued here other than to maintain that

58. Bertrand Russell, *Religion and Science* (New York, 1935), p. 250.
59. Elisabeth Schneider, *Aesthetic Motive*, p. 86.
60. On this point the reader should consult Joan Evans, *Taste and Temperament* (New York, 1939), and A. M. Bodkin "The Relevance of Psycho-Analysis to Art Criticism," *British Journal of Psychology*, XV (1924–25), Pt. II, 174–183.

critics who attempt to instill even an ideal of absolute stand-
ards and evaluations upon the unknowing and untrained may
distort wholesome and just esthetic attitudes, and that a
teacher who informs pupils that one kind of art is intrin-
sically superior to another may be doing positive and per-
manent harm.[61]

61. Still another objectivist argument asserts that evaluations become pro-
gressively better from age to age because of an accumulation of critical
knowledge. I shall not consider this argument, which seems to me thoroughly
unsound and to be very largely based upon self-flattery.

II. SUBJECTIVISM

WHAT then are the alternative possibilities? Contrary to much current belief, there exist at least two further general positions, which differ markedly from one another but which agree in one essential doctrine: namely, that all values are empirical phenomena inextricably linked with human behavior and experience. This common denominator may be responsible for the loose employment of the terms "subjective" and "relative" interchangeably in philosophical and critical writings and for the fact that they are so seldom defined with accuracy. When it is realized, however, that major differences exist between two theories which are both opposed to absolute objectivism, the desirability of using these two terms in distinct, separate ways should become apparent.

Briefly, what meaning has subjectivism for value theory and for art criticism? Common to its slightly varied forms is the idea of value as an immediate emotional state which delights, as a "felt satisfaction," as a "feeling present to attention." Such definitions are clear, explicit, intelligible. For criticism they harmonize well with those facts which proclaim the extreme diversity of cultural values and tastes since, if value is a feeling in the subject, there should be no reason to expect or to require uniformity of opinion. Evaluations become a matter solely of individual personal preferences: what *I* like is good and what *I* prefer is better.

The task for the critic is then one of expressing in words the sensations communicated to him by the object: the detailing, as for Anatole France, of "adventures among masterpieces"; and the result, at best, is the sort of impressionistic autobiographical appreciation advocated by Pater: " 'The aim of all true criticism' . . . is to inquire 'what is this song

or picture, this engaging personality, to *me?* Does it give me pleasure, and if so, what sort or degree of pleasure? How is *my* nature modified by its presence, and under its influence?' " [62] Now, while criticism of this kind may be stimulating and enlightening in the hands of a genius like Pater, it is unrevealing, cloying, and even exasperating in the work of an average writer like Clive Bell, as the following passage upon Raphael's "Bible" in the Vatican Loggia proves:

Let us just look at the ceiling for one moment to see whether we cannot feel the authentic touch in *The Creation of Eve* and *The Fall*—for my part I prefer them almost to Michelangelo's versions —and whether we do not catch a breath of superior inspiration in the design of *The Finding of Moses, David and Goliath* and *Bathsheba.* If, perversely, you pretend rather to find a touch of David in *The Judgment of Solomon* I am in too good humour to protest. But I must tell you that, though I know it is wildly improbable that Raffael ever put his brush to a single one of the grotesques, I adore them all. [63]

In such critical theory and practice there is evidently no question of intrinsically objective standards. Upon what ground, then, do certain subjectivists claim final validity for their views? How is it that Kant and his followers considered the "judgment of taste" at once subjective and universally valid? Or that contemporary subjectivists, like Bell, talk about the "absolute value" of the "esthetic thrill"? All such opinions, which may differ considerably in appearance, are based upon the presuppositions that all superior minds are similarly constituted and that, therefore, they will or should present uniform and correct evaluations. At this point objectivism and subjectivism join hands: both theories hold that their appraisals are eternally true; both base their convictions

62. Quoted by E. E. Kellett, *Fashion in Literature,* p. 20.
63. *Enjoying Pictures,* p. 81.

in large measure upon sheer intuitive certainty. Thus it is interesting but not surprising that certain objectivists, or rather pseudo-objectivists, grant that all artistic principles arise in the human mind. As Sir Joshua, who is at pains to defend the strictest sort of rules, remarks: "What has pleased, and continues to please, is likely to please again: hence are derived the rules of art, and on this immoveable foundation they must ever stand." [64]

Any criticism, however, which seeks a more definite and substantial foundation for appraisals will repudiate as *inadequate* all subjective insights, for these latter are an insufficient basis for criticism regarded as reasoned discrimination and estimation. These intuitive insights, to be sure, may be called "judgments," if "judgments" are defined in terms of the senses or of mere liking; but if "judgment" is considered to any extent a rational, intellectual activity, they are emphatically not judgments at all. Rather, they are exclamations expressive of approval or the reverse and "may be stated in judgments if we wish to go to the trouble to do so, instead of merely exclaiming 'Ouch!' or 'Ah!' or 'Phew!' or 'Stunning!'" [65] Indeed the conclusion seems inescapable that subjective theory supports a *de gustibus non est disputandum* attitude which renders impossible in criticism reflective judgments, value propositions, and any concept of standards or validity which is more than personally binding. Training, discriminating perception, education, thought, and knowledge are then critically irrelevant, so that, as John Dewey truly says, "The conception that mere liking is adequate to constitute a value situation makes no provision for the education and cultivation of taste and renders criticism, whether esthetic, moral, or logical, arbitrary and absurd." [66] When this

64. *Discourses,* VII, p. 209.
65. J. R. Reid, *A Theory of Value,* pp. 211–212.
66. "The Meaning of Value," *Journal of Philosophy,* February, 1925, p. 131.

dilemma is squarely faced by the subjectivist Reid, it is impor-
tant and instructive to notice that some prizings are found to
be better than others only "with reference to some particular
prizing accepted at least for the time as a 'standard,' " [67]—a
statement which contradicts his otherwise consistent disbelief
in standards, and which is properly suited, as we shall pres-
ently see, rather to a relativist theory of value.

In asserting that the crucial problem of criticism concerns
"varying forms, and degrees, of order in the personality,"
Richards advocates an important critical idea which is psy-
chological, hence, in a way, subjective in character. But the
critical theory we are considering no more enables one to
judge order in the personality than it enables one to judge
data outside of the mind. Moreover, while Richards' prob-
lem is significant and is not invalidated, in my opinion, by the
unsympathetic analyses in recent years of D. G. James, J. C.
Ransom, and other critics, the subjective emphasis which
makes evaluative judgments a matter of comparative re-
sponses, and criticism a branch of psychology, tends to divert
one's attention from the relatively objective side of the value-
situation—the work of art. In this connection, therefore, it is
heartening to an art historian to find that the psychologist
Koffka not only stresses the interdependence and "connected-
ness between the Ego and an object," [68] but that he empha-
sizes primarily the "structure" of the art object rather than
the emotion it arouses.

Other problems for which subjectivism cannot justly find
plausible solutions are: why is it that certain works of art con-
tinue throughout the centuries to be highly praised and thus
receive an established reputation? how is it that tastes tend to
change in one direction only, let us say from Pinturicchio to
Piero della Francesca but seldom vice versa? or why do all
trained critics agree that there are emotionally powerful yet

67. J. R. Reid, op. cit., p. 242.
68. "Problems in the Psychology of Art," p. 202.

cheap responses which prevent the many from enjoying the "finer things in life" if these "finer things" are not in some sense, other than a purely personal one, better? Intelligible and satisfying answers to these questions connote significations for "good" and "bad" and hence for judicial criticism which cannot logically be deduced from a consistent subjective theory of value.

III. RELATIVISM

FOR various reasons, then, both objectivism and subjectivism are invalid. Merely indeed on the *a priori* evidence that, roughly, 40 per cent of all philosophers and critics subscribe to one of these theories and another 40 per cent to the other, one might suppose that both camps are mistaken (somewhat as the incompatibility of the dogma of original sin and the doctrine of the goodness and perfectibility of man suggests the incorrectness of both alternatives and points toward another interpretation of human nature). A third possibility, which is by no means merely a *via media* between the two extremes previously discussed, but an original position of a different kind, is "relativism."

In broadest view, this theory avoids the mythical absolute values of the objectivist and the irresponsible preferences of the subjectivist through new interpretations of both the valuable object and the valuing subject and by an emphasis upon the interrelation between them in a total situation. One can separately describe two different though connected aspects of relativism.

First, according to the relatively objective side of its thesis, value is defined as a relational property of an object in the same way that nourishing is a relational, not a real property of food; in other terms, the work of art has potential value which becomes actual only in a transaction with a sensitivity. One may refer, as we all do, to the value of an object, but the intended meaning should be that the value quality is partly dependent upon an experiencing subject. This interpretation of value, which is analogous to the definition of relatively objective properties given in note 41 is somewhat differently explained in the following passage:

The values things embody for us are objective qualities of things, as real to us as are rocks or trees or giant pandas. But not more real nor more eternal—and it is at this qualification that the traditionalists stick. They are imbued with the Platonic prejudice and hold the impermanent to be unreal, imputing full reality only to the eternal. The naturalists argue that values are no less real if they are fleeting episodes dependent on human needs, themselves fleeting episodes in cosmic history, than if they were as old as the universe itself and could only perish with it.[69]

The second side to the theory,[70] which may be called the relatively subjective aspect, considers value a function of animal interest, but distinguishes valuing from mere liking and feeling in two ways: first, by stressing the dependence of the valuing upon the properties of the object, by accenting, that is to say, the character of the evaluation as an inter-action between a valuable object and an attitude; second, by holding that, while liking is still a necessary condition for the activity of valuing, it is emphatically an insufficient one. In addition, thoughtful reflective inquiry upon the total situation must be present in order to give genuine significance to values. An essential contrast to subjectivism is thus made by underlining a rational factor in the value situation. This second contrast to subjectivism may be further elucidated by opposing the meanings of certain pairs of words, the first word in each case indicating subjectivist "liking" or "taste," the second relativist "approbation" or "judgment": "desired" and "desirable"; "satisfying" and "satisfactory"; "admired" and "admirable." Interpreted in this way, value theory can give meaning to our desires for improvement, to our strivings for and preferring something better, and so can explain the

69. Eliseo Vivas, "The New Naturalism," *The Kenyon Review*, Autumn, 1941, p. 454.
70. What follows is a summary of a portion of John Dewey's "Theory of Valuation," *International Encyclopedia of Unified Science*, II (1939).

enormous importance of training and of cultivation of taste for criticism. In other words, "Theory of value and theory of criticism coincide; to value is to appraise, the good is the better—neither can be accounted for except in terms of the other." [71] Such a statement superficially seems to, but does not in fact imply objectivism, for good and bad, better and worse are never referred to exclusively external or absolute standards but are always considered in their relation to a specific concrete subject-object situation.

Having outlined the relatively objective and relatively subjective sides of relativist theory, we may now consider those aspects of relativism which bear directly upon the problem of critical evaluations and ask: what will a relativist art critic mean by good and bad? in precisely what sense may we believe that value judgments are better and worse, valid and invalid?

(A) "Logical" Relativism

To begin with, the critic should recognize the need for some standards, principles, or criteria[72] to serve as a guide and foundation for any appraisal. His specific judgments should be informed by some theory which will explain his

71. O. A. H. Pell, *Value-Theory and Criticism* (New York, 1930), p. 50.

72. Various distinctions in meaning between these and similar terms can be and have been made on the bases (a) that some critical concepts are more fundamental or broader in scope than others, (b) that in any single critical system the more specific and particularized elements are logically deduced from the more general beliefs and definitions, and (c) that the ideas of quantitative measurement and qualitative judgments should be carefully differentiated. But as the distinctions in meaning do not seem to me fixed, and as I am anxious to avoid inordinate verbal repetition, I use these words in a flexible and largely synonymous sense which is made clear, I trust, by the context. Nowhere, however, do I mean anything so vague as the physiological standards of the subjectivist, which J. R. Reid defines as "motor-affective patterns, organic habit-systems, which constitute the inner determinants of a critical response, determining our likes and dislikes, what we accept and reject" (*A Theory of Value*, p. 288).

critical position and define what he regards as the functions of art: whether, for instance, art shall convey "truth" or whether its sole purpose is to present a satisfying surface pattern. Or, working at a somewhat less generalized level, the art critic should explain his attitude, where it is pertinent, toward problems of the following sort: the possible significance of the medium, the place of subject matter in art, the relation of form to content, the advantages and drawbacks of realistic or abstract types of representation, and so forth. Provided the critic defines with great care the meaning he attaches to all such questions, the solutions to them may be formulated as criteria which will be immensely useful; for with these criteria as a basis of artistic evaluations, judgments can be made which will indeed be "relatively objective"— relative in that they depend upon deliberately chosen standards, objective to the extent that they can be empirically checked with these by the trained critical expert. The necessity and usefulness of these standards is succinctly explained by John Dryden: "For how was it possible to be decided who writ the best plays, before we know what a play should be? But, this once agreed on by both parties, each might have recourse to it, either to prove his own advantages, or to discover the failings of his adversary." [73]

The writings of Tolstoy and of Berenson may be cited as typical yet diverse instances of the correct method of approach. In *What Is Art?* Tolstoy makes many judgments with which most of us will wholeheartedly disagree; nevertheless they are neither incomprehensible nor harmful, since they are based upon a specific theory about art and life which, even if we deem it misguided, is intelligible. "All that I have written," he says, "I have written with the sole purpose of finding a clear and reasonable criterion by which to judge

73. "An Essay of Dramatic Poesy," *English Critical Essays*, (The World's Classics), p. 129.

the merits of works of art." [74] Berenson, a very different critic, shares the laudable trait of making evident his principal standard for evaluating painting: a life-communicating quality which is expressed mainly by tactile values, movement, and space composition. How helpful in explaining divergent judgments such criteria may be is evident from Berenson's comment regarding the bandages about the heads of figures on the Sistine ceiling: "To Ruskin, I am told, these were a source of great offence, but to me they are a source of delight, for they communicate an ideated sensation of pull and resistance which vitalize the forms they enclose, and make me feel more alive." [75] If we also know the basic suppositions of Ruskin's criticism, we can then readily comprehend his evaluation as well as the opposed one of Berenson. In short, artistic judgments of good and bad have intelligible meaning only when art objects are interpreted in the light of some critical system which should be made explicitly or implicitly clear. This axiom might be called "*logical* relativism."

To illustrate further the effect that disagreement in critical postulates has upon specific evaluations, consider the opinions of Walter Abell and of Lionello Venturi upon two paintings of the "Agony in the Garden," one by El Greco, the other by Perugino. [76] In his brilliant analysis of these

74. *What Is Art?*, p. 248.
75. *The Drawings of the Florentine Painters*, I, 196.
76. For these opinions, see Abell, *Representation and Form*, pp. 85–89 and 128–131; and Venturi, *Art Criticism Now*, pp. 43–46. "Associative form" is briefly defined in this book, p. 80.
From remarks made elsewhere in this book, it is evident (i) that I agree with Abell in this controversy, but (ii) that, as a relativist should, I grant the legitimacy of Venturi's critical system as the expression of an acute critical sensitivity. On two scores, however, Venturi's attack upon Abell should not be exculpated; and these scores are worth noting because of Venturi's present considerable authority in matters regarding art criticism: (a) Because Abell expressly states his indebtedness to four modern writers,

works, Abell compares their associative form: he contrasts, for example, the dramatically intense action, the emphasis upon the spiritual characterization of Christ, and the appropriately "oppressive" setting of the El Greco, with the meditative tranquillity, the lack of emphasis upon the character of Christ, and the "inviting" setting of the Perugino. And he concludes from these and other comparisons that El Greco's is a finer painting because, by contrast with Perugino's, all its elements fuse into a single unified conception which reinforces "a visualization of the world as it would seem to one in the position of Christ." In challenging Abell's conclusion, Venturi argues that the relation of the elements in the painting to "the position of Christ" or to "the feeling of Christ" is artistically irrelevant in that the only legitimate point of reference for these elements is the personality or style of the artist. Since this point of reference, says Venturi, is the true measure of artistic judgment, many different, yet equally perfect versions of the "Agony in the Garden" exist; were Abell's position tenable, however, El Greco's version would be the only perfect one.

The cause of these diverse appraisals in comparative value is now clear: the critics are judging by different standards. Abell rates the El Greco above the Perugino on the basis of a standard of artistic significance,[77] whereas Venturi praises them equally in terms of artistic perfection. Abell considers, that is, not only the success with which the artist has achieved his aim, but the depth and profundity of his conception as well, whereas Venturi evaluates entirely according to the intent or purpose of the artist. Hence, as logical relativism

Venturi unjustifiably assumes that Abell has consulted *only* these four writers in the esthetic field. (*b*) With characteristic Crocean assurance, Venturi calls Abell's work "well-meant" and his esthetic conclusions absurd, distorted, and false. The effect of such dogmatism, which will be mentioned again in the discussion of "psychological" relativism, is anything but critically beneficial.

77. The standards of artistic significance and artistic perfection are discussed in this book on pp. 77–82.

teaches, these varied principles lead directly to equally varied evaluations.

Further analysis of the required standards shows that they are both derivative and tentative. They are derivative in that they result from human choice and are, therefore, merely codified judgments of expert critics. Moreover, they are derived by induction from concrete situations in relation to which they should never be regarded as external. In the words of John Dewey, these empirical principles "are not rules or prescriptions" and "are of use as instrumentalities of personal experience, not as dictations of what the attitude of any one should be." [78] Therefore they are subject to constant revision or extension, so that our aim should be not only to apply our chosen criteria but equally and constantly to test them by our appraisals. If theory does not support a penetrating and carefully considered insight, by all means modify the theory rather than distort evaluations in order to fit them into a predetermined hypothesis. Thus there is a delicate balance, a fine adjustment which the critic should strive to attain in a conception of standards which at once inform his judgments yet are capable of immediate modification by these.

The procedure of the two critics who were earlier praised for recognizing the importance of standards in criticism, diverges in respect to the tentative character of these standards. In his famous indictment of Beethoven's "Ninth Symphony," Tolstoy's verdict seems warped because of the compulsion he feels to bind a specific appraisal to a previously determined and rigidly fixed criterion. In judging the symphony, he says:

Since this work does not belong to the highest kind of religious art, has it the other characteristic of the good art of our time—

78. *Art as Experience,* p. 309.

the quality of uniting all men in one common feeling—does it rank as Christian universal art? And again I have no option but to reply in the negative; . . . And therefore, whether I like it or not, I am compelled to conclude that this work belongs to the rank of bad art.[79]

Berenson, on the contrary, seems to realize that criteria are, to a degree, tentative: "He does not possess a hard-and-fast doctrine: he explicates and modifies his thinking as he goes along, and if his experience of the particular painter with whom he is concerned at the moment seems to demand an explanation which does not immediately tally with some previous explanation, he does not hesitate (as a doctrinaire might) to bring it forward." [80] In Berenson's criticism, for example, artistic content is usually of subsidiary importance; when appraising certain artists, however, he modifies this usual position and applauds the rendering of the "literary," "human," and "spiritual" values.

(B) "Psychological" and "Sociological" Relativism

Implied by and connected with the derivative and tentative nature of relativist criteria is their *psychologically* relative character. In order best to explain this aspect of the necessary empirical standards, the relativist must first make a philosophical assumption. He will assume (on the basis of what seems to him overwhelming evidence) that there exist a number of better kinds of people; hence he will draw the conclusion that no one can justifiably claim superiority for any single psychological type. George Santayana expresses this view in a memorable passage:

The lion and the eagle were ideal in their way: so were the gazelle and the lark in theirs. Who should say which was better?

79. *Op. cit.*, p. 249.
80. Howard Hannay, *Roger Fry and Other Essays* (London, 1937), p. 68.

Better in what sense, according to what standard? In one mood you might say: Better be like Jim Darnley, fleshly, since you are living in the flesh, hard enough, coarse enough, loose enough to feel at home in the crowd. In another mood you may say: No: better be like Mario, refined by nature, clear as a crystal, merry without claims, brave without armour, like the lilies of the field or the lilies of Eton. Or in yet another mood, why not think it better to be as Oliver himself was, burdened but strong, groping but faithful, desolate but proud? [81]

Now to whatever extent we believe that all men should be mentally and spiritually alike, to the same extent shall we probably endorse a uniformity of artistic principles and evaluations; for critical conceptions to most of us are relative in the same way and to the same degree that human nature, human ideals, and human ideas are relative. Thus most objectivists, with perfect consistency, will hold that neither ethical nor artistic standards are to the slightest degree relative, whereas most relativists will believe in the validity of varied standards both moral and artistic. These latter will differ according to fundamental cleavages in types of expert critics.

We may illustrate this psychological relativity in critical principles by briefly summarizing two contrasting and representative attitudes toward art and esthetics. For Coomaraswamy, "Art has to do primarily with knowledge, and only accidentally with feeling";[82] it must be controlled by the intellect and must never be irrational. In the next place, art should reveal reality and truth. The real things which art will imitate are the divine originals or Platonic Ideas which are contrasted with the unreality of mere appearances. And thirdly, again following Plato, and rejecting the distinction,

81. *The Last Puritan* (New York, 1936), p. 319.
82. The quotations from Coomaraswamy are taken from a lecture entitled: "Figures of Speech, or a Figure of Thought?"

first made by Aristotle, between useful and fine art, "The judgment of art is by its value for good use," so that no art is worthy of the name which is not only beautiful—which is interpreted as meaning "perfect" and is "a matter of accuracy"—but useful and "effectual" as well. The emphasis everywhere, in short, is upon the intellectual, the moral, the practical. In this and the many allied interpretations of art according to which the human significance, the reality, and the "truth" expressed by the content are of primary importance, I am reminded of my first instruction in the history of art which began when the professor dramatically posed and answered the question: "Gentlemen, what is painting? It is the expression of non-material values by means of visual ones."

Contrast these opinions with those art theories that are formalistic, accenting formal aspects of artistic organization and their appreciation by means of the "esthetic attitude" or "esthetic experience," which is characterized as a special sort of contemplation or perception and is distinguished more or less sharply (according to the inclination of the individual critic) from experiences which are intellectual, moral, political, social, or practical. Accordingly, art becomes something quite different from Coomaraswamy's notion. We find not merely that disinterested perceptual contemplation is the goal of artistic experience, but that emotion is more important than knowledge and that esthetic pleasure, rather than the revelation of reality and truth, is the evaluating standard. And finally, the intellectual, moral, and practical aspects of an art object are ignored as irrelevant to artistic appreciation, or are perhaps classified as "derived esthetic values" which should be held subsidiary to the fundamental direct perceptual ones.[83]

83. On this point, see H. N. Lee, *Perception and Aesthetic Value* (New York, 1938), chap. vii.

Now neither of the above theories is false, according to relativism, since each presents general conceptions which underlie intelligible, sincere, and intelligent explanations of important experiences. Untruths appear only when critics contend that theirs is the *only* correct or true way of observing and appraising art. Knowing that Coomaraswamy is an objectivist, one should expect his assertion that the "true philosophy of art is always and everywhere the same"; yet surprisingly enough this is also the explicit or implicit attitude of many a scientific empiricist. Because this attitude is widespread, we find in criticism today the prevalent spectacle of the intellectual-moral critic blasting the opinions of his formalistic adversary as being superficial or even "unintelligible," while the latter retorts that "the moralistic view of art is the immoral recourse of thinkers with moral axes to grind" [84] who are incapable of "pure" esthetic responses. Against such polemics the less prejudiced mind will decide that "nothing is more certain amid uncertainty than that the inability to appreciate, in due fashion and measure, what others appreciate—in fact, to enter sympathetically into the minds of our fellows—is a *dis*ability, something to be ashamed of rather than to be boasted about"; [85] and the less prejudiced mind will suggest that basically different standards among expert critics are inevitable because of fundamental philosophical and psychological differences, i.e., what Hume called "the different humours of particular men." [86] In other words, there exist a number of conflicting yet genuinely

84. J. C. Ransom, "Ubiquitous Moralists," *The Kenyon Review*, Winter, 1941, p. 99.

85. Kellett, *Fashion in Literature*, pp. 79–80.

86. Unfortunately, as J. S. Mill observed, "Metaphysicians . . . while they have busied themselves for two thousand years, more or less, about the few *universal* laws of human nature, have strangely neglected the analysis of its *diversities*" ("Thoughts on Poetry and Its Varieties," *English Critical Essays* [The World's Classics], p. 416).

superior artistic principles which have been evolved as a result of sensitive and trained experience, reflective inquiry, and cultural equipment. Between such principles definitive judgment cannot justly be made.

One may specifically and usefully apply the principle of psychological relativism by considering the divergent Chinese and western attitudes toward the painting of birds and flowers.[87] Contrary to us, the Chinese, because of their almost equal interest in all forms of life, hold that *living* birds and flowers are among the most important artistic subjects and use them, consequently, as the themes of large, monumental works. *Still* life, on the other hand, is abhorrent to the Chinese, who require of art living associations in the things represented: thus in Chinese writings, we find references to the "gentleman bamboo." The Chinese want associative overtones, that is to say, which plastic form alone does not provide; and for this reason, they tend to disparage western artists like Chardin. Moreover, if we compare, say, Sung Chinese and post-Renaissance western representations of birds and flowers, we observe four main differences: (i) The Chinese are indifferent to artistic "self-expression"; though their interest in human associations is great, expressionism in bird and flower painting (as in the flowers, for example, of van Gogh) is for them a too personal and insufficiently generalized artistic style. (ii) In contrast to the seventeenth century Dutch fondness for an abundance of natural details, the Chinese represent only a few living birds and flowers and stress the importance of voids and space. (iii) In their compositions, the Chinese are uninterested in the balance and symmetry of western unity; their unity is based, rather, upon a fusion or equilibrium of tensions. (iv) The Chinese consider plasticity and rich color harmonies (as in the still life of Cézanne) of negligible importance because, for them, the

87. I am indebted to Professor George Rowley's analysis of the following distinctions.

"life rhythm" of the birds and of the ink bamboo is the characteristic above all others which artistically matters.

The foregoing contrasts between Chinese and western painting point to different, if not entirely opposed standards of evaluation. Should the critic then attempt to show that either the Chinese standards or our own are the correct, valid, or true ones? Or may he claim that one set of standards is absolutely superior to the other? Whereas the objectivist will be so brash as to answer these questions in the affirmative, the relativist will understand the futility and the impertinence of pronouncing categorical judgment upon two such divergent and sensitive artistic approaches. The relativist will recognize the essential dependence of each approach upon the culture of which it is a part: he will see, for example, that the Chinese artistic requirement of an animated nature and the western artistic interest in inanimate particularities are influenced respectively by Chinese nature philosophy and by western science. Doubtless this critic will *like* and will probably even *approve* one artistic approach more than the other; and in that event, applying the principle of *logical* relativism, he will explicate his value judgments with reference to his chosen criteria. But, applying also the principle of *psychological* relativism, he will admit the legitimacy of the claims of differing cultures and sensitivities, will understand the superior quality of each set of claims, and will realize that his judgment can reasonably be binding only for those people who, as a result of fundamental similarities in their temperament, education, and environment, basically resemble him.

Confusion resulting from failure to grasp and apply this principle of psychological relativism may be concretely illustrated by two examples from current literary criticism, which, in general, is decidedly more acute, illuminating, and mature than current art criticism. In a single volume, *The Intent of the Critic,* the postulates of Edmund Wilson, Norman

Foerster, John Crowe Ransom, and W. H. Auden are clearly set forth. Granted that the different critical approaches of these writers may up to a point result in collaboration rather than rivalry, nonetheless certain basic conflicts among their principles, e.g., the opposed views of Foerster and Ransom as to the place and importance of ethical standards in criticism, can only be satisfactorily accounted for by relativist theory. Such disagreements are irreconcilable and cannot be sensibly explained by absolutism. Yet three of these critics, blinded perhaps by "metaphysical cobwebs," appear to be absolutists; each one apparently holds that he is revealing *the* proper, decisive, and true function of criticism.

The second example which ignores the possible salutary effect of psychological relativism is T. S. Eliot's comment upon Classicism and Romanticism: "Either one attitude is better than the other, or else it is indifferent. But how can such a choice be indifferent?" [88] This dilemma is of course inescapable for the absolutist: one "of the two antithetical views" must, for him, be "right." Relativism teaches, on the contrary, that the relative value of both views is neither indifferent, nor eternal and intrinsic, but is dependent upon the temperament of the experiencing individual. Therefore when the experiences and appraisals of judicious critics diverge, why conclude that one or the other is wrong rather than that each is accurately describing his own experience and that the valuable experiences of equally sensitive individuals necessarily differ in fundamental ways? Were this position more widely accepted, traces of humility might filter through the irritating arrogance of the usual esthetic treatise which so often appears more like a case history than a reasoned argument. Rare, indeed, in writings upon art and beauty, is the humility expressed in a remark by Roger Fry: " 'I feel so infinitely less confident about anything I have to

88. *Selected Essays,* p. 17.

say than I used to be. It's dreadful how diffident getting a little deeper into things makes one—one sees too much to say anything.' " [89]

As a final example of the misguided dogmatism which usually results when the principle of psychological relativism is ignored or discarded, I shall cite Mrs. Langer's discussion of music.[90] According to her view, music is symbolic; it is denotative and connotative rather than emotional; it "is not self-expression, but *formulation* and *representation* of emotions, moods, mental tensions, and resolutions"; and its content invites "not emotional response, but *insight.*" Now Mrs. Langer's analysis of this position is suggestive, acute, and stimulating; and the position is applicable to a great deal of musical creation and response. Moreover, from the brief consideration earlier in this book of works of art as symbols, it is evident that, to a large degree, I am in sympathy with her approach. What I object to, then, is not her exposition of music as symbolism, but her claim that a different, though widely held approach toward music should be ruled out of court. Though at one moment she condemns critics for *entirely* rejecting her symbolic interpretation of music, at other moments she herself *entirely* rejects the interpretation of music as self-expression. And she does so in the face of such powerful testimony—which she herself cites—as the following:

From Rousseau to Kierkegaard and Croce among philosophers, from Marpurg to Hausegger and Riemann among music critics, but above all among musicians themselves—composers, conductors, and performers—we find the belief very widely disseminated that music is an emotional catharsis, that its essence is self-expression. Beethoven, Schumann, Liszt, to mention only the great, have left us testimonials to that effect.

89. Woolf, *Roger Fry*, p. 286.
90. See Susanne Langer, *Philosophy in a New Key*, chap. viii.

Despite this evidence, Langer nowhere suggests that the interpretation of music as self-expression is under any circumstance permissible; she nowhere recognizes the possibility —which seems so obvious to a relativist—that differing though equally sensitive persons will respond to music in differing ways and that, therefore, more than a single critical attitude is justified. On the basis, for example, of M. Focillon's conviction that the standpoints of the artist and of the critic usually differ greatly, one may reasonably believe that a musician who consciously expresses an *emotional catharsis* may communicate *insight;* or, as another possibility, the reverse situation might easily occur. In her zeal, moreover, to bolster her own position, Mrs. Langer, like many other critics with a comparable aim, is unfair to the opposition. Thus her exposition of music as self-expression distorts that view by contending that music thereby becomes "sheer self-expression," is identical with expressions like "oh, oh," and is void of any "formalizing" characteristics. Such are the dangers of philosophical and critical dogmatism.

In stating or discussing his critical position, then, the relativist realizes that his convictions neither can nor should have general validity, but that they hold only for those who are similar to him in certain basic ways. That is to say: in order that successful communication and a reasonable amount of agreement in regard to critical systems and to specific evaluations may occur, sufficient similarity in cultural environment, in philosophical outlook, and in psychological temperament must exist. For this reason, it is unlikely, let us say, that the critical opinions of those experts who consistently judge art primarily by its content will ever be brought into harmony with those differing opinions of other experts who consistently judge art primarily by its form. The evaluations of any one critical group, in short, do not hold for a differently constituted group.

Consequently it is not inevitable, contrary to the tenets of

many a critic, that we should always be searching for absolute or universal values. For relativism recognizes and takes account of the previously mentioned fact that values are largely conditioned by and relative to specific cultural groups and periods: "When the social dimension is given its rightful place in value theory it is not difficult to see that correct value judgments are valid for the society within which they are uttered, because they express the interests of a social self." [91] But as societies widely differ, so will evaluations radically change. Thus Hume, who in fact attempted to fix a standard of taste, nonetheless saw that judgments will vary because of "the particular manners and opinions of our age and country." [92] Seen in these lights, relativist theory satisfactorily explains the large amount of diversity among expert appraisals; and relativism may now be further distinguished from both objectivism and subjectivism by the spread and duration of its validity: whereas subjective values are logically binding only for the individual and for the moment, and objective values are binding universally and eternally, relativist ones are binding for particular groups of people during a particular cultural age.

Since, however, the beliefs of a relativist *are* binding and valuable for himself and for particular groups of individuals, explicitly or implicitly stated criteria not only clarify specific valuings; they also present critical ideas which themselves may be revealing and enlightening to many people. For example, it seems to me possible and desirable to urge that artistic theories which are concerned exclusively with either content or form advocate standards which are inadequate as bases for the finest artistic judgments. Empirical evidence demonstrates to my satisfaction that the richest artistic experiences involve an appreciation of *both* content and form

91. Eliseo Vivas, "The New Naturalism," p. 453.
92. "Of the Standard of Taste," *Essays* (London, 1875), I, 280. T. H. Green and T. H. Grose, eds.

and that, therefore, significance of content as well as perfection and significance of form is indispensable to the greatest art. Thus I believe, on the one hand, that limitations in moralistic systems may be revealed by explaining the crucial importance of the esthetic attitude for artistic experience; and I believe, on the other hand, that limitations in formalistic theories may be exposed by plausibly showing that formal or plastic form is not a sufficient condition, although it is a necessary one, for artistic creations and experiences of the highest order.[93]

In exactly what sense or to exactly what degree such beliefs may fairly be considered valid is a puzzling problem. One is tempted to think that those principles which are held by many and variously constituted critical experts are the better ones; certainly they are more universal, hence more useful as vehicles of communication. In *The Novel and the Modern World*, Professor David Daiches makes interesting remarks upon this aspect of the evaluation of artistic standards. He shows, to begin with, that the varied standards of the most distinguished contemporary novelists are highly limited. He explains, for example, that James Joyce abandons normative standards of significance by adopting an excessively "art for art's sake" point of view, and that Virginia Woolf, although having for a criterion "Is life like this?," nonetheless "refines on values" to an extreme degree. The important judicial question then becomes: does the limited nature of criteria also signify inferiority? Unquestionably the works of Joyce and of Woolf are too personal to be easily appreciated (though they are not, as Daiches asserts, "purely personal"). *Quantitatively*, therefore, the criteria of these artists are inadequate by comparison with more traditional types. But is there sound justification for holding that restricted principles are necessarily inferior *qualitatively?* I think not. Contrary to

93. For an admirable defense of this intermediate position regarding form and content, see Walter Abell, *Representation and Form*.

Daiches, I suggest that such principles may stimulate the creation of works of art which will be as valuable for certain sorts of good minds as will other art objects for those who, like Daiches and myself, subscribe to more normative standards. To be specific: since much evidence indicates that the best abstract art communicates intensely valuable artistic experiences to a number of highly sensitive individuals, it seems reasonable to hold that those critical principles which encourage the creation of such art are superior ones.

But if the competent critic should apply the principle of psychological relativism when judging all *superior* standards, he may pronounce *definitive* judgment upon those *inferior* ones which depend upon crude and untrained experience, hasty intuitions, and cultural ignorance. For irreducible relativity emphatically does *not* imply that one criterion is as good as the next. If the relativist assumes, as stated above, that there are a number of better kinds of people, he also assumes that some minds are finer than others—more intelligent, subtle, sensitive, orderly. Thus, while the expert critic will admit the basic relativity of differing attitudes all of which are intelligible, sincere, intelligent, and the like, he can distinguish these from other attitudes which are unintelligible, insincere, and unintelligent. The irrelevancies, eccentricities, and fallacies of these latter can be explained by any skilled critic and the standards repudiated with assurance. For example, the relativist might assert or, if necessary, prove that artistic judgments which are based *preponderantly* upon what the observer conceives to be the importance of the subject matter are crude. Or again, the critic might justifiably insist and effectively argue that an esthetic system which evaluates paintings *preponderantly* according to resemblances of one sort or another to the visual world is an insensitive and uncultivated one. Or, to cite a specific case, some of the standards and evaluations so arrogantly presented by Mr. Thomas Craven in his volume *Modern Art* are inferior ones:

these standards implicitly identify artistic form with technique, process, or method; they reveal, consequently, a monumental inability to appreciate the artistic value of formal aspects of works of art and they render the wholesale condemnations of such distinguished painters as Matisse and Picasso worthless.

Even in regard to these inferior sorts of criteria, however, one might plausibly argue that the case for dogmatic judgments against them has been overstated. Granted that almost no judicious critic today would set up unqualified verisimilitude as a principal standard by which to judge painting, how are we to interpret and appraise the emphasis placed by Alberti and by Leonardo upon a complete and exact imitation of nature? Or what are we to think of William Hazlitt's axiom that "the value of any work of art or science depends chiefly on the quantity of originality contained in it"? [94] It is easiest and most natural (since one tends to consider his own opinions intrinsically superior) to believe either that such opinions of competent critics are intrinsically inferior, or that, possibly because of semantic difficulties, we have misinterpreted them—by supposing, for example, that when any critic stresses the artistic importance of imitating nature, he is referring to an exact transcript of objects rather than, like Aristotle, to an ideal imitation of things "as they ought to be." But another solution to the problem seems more reasonable: namely, as suggested earlier, that certain evaluations differ primarily because of different "social dimensions": the evaluations are relative *sociologically* in that basic cultural changes effect basic changes in evaluation. Thus certain values which are correct for one society will be incorrect for another dissimilar society. There arises, consequently, a difficult and delicate problem of differentiating those standards which are produced by crude responses from those which were genuinely superior for one culture yet are

94. *Essays on the Fine Arts*, p. 127.

inferior for another. Luckily the problem is of secondary importance since, whichever alternative is true, the critic of any particular time and place must explain why, for his own culture, certain canons and creeds are better than others.

In another respect, finally, psychological relativism differs from both subjectivist and objectivist theory. By recognizing the presence in human beings of emotional and intellectual forces which are widely held and which give an important kind of continuity and stability to artistic creation and response, psychological relativism rejects that anarchy in critical postulates which subjectivism logically implies. There are certain experiences and associations, that is, of an "archetypal" character which art expresses and communicates. In her book, *Archetypal Patterns in Poetry*, Maud Bodkin considers such well-organized and relatively stable patterns or images as those of Heaven and Hell, Woman, the Devil, the Hero, and God; and such patterns evidently occur also in painting and in sculpture.

Recognition of archetypal patterns in art, however, in no essential way supports objectivism, because (i) though *widely* held, these patterns are not, contrary to the opinion of Bodkin, *universally* held *even within* a single racial mind or inheritance: thus any belief today in God or the Devil is repudiated by many competent artists and critics; and (ii) the multiplicity rather than the homogeneity of interpretation given to each of these broad archetypal patterns is significant for criticism and for value theory: thus the diverse conceptions of an archetypal image of God at once motivate the production of very different kinds of art and point to that basic diversity of cultural attitudes which, we have seen, is of paramount importance in producing divergent value judgments.

(C) *The Relevancy of Criteria*

Up to a point, then, the expert critic should attempt to evaluate criteria. But he may do more than this. On the basis, once more, of empirical evidence, the relativist will maintain that some critical conceptions are more universally applicable than others, depending upon the kind of art being considered, and that while there is partial justice in many claims, each theory is too limited, each standard too restricted to serve as a tribunal before which all the varied forms of art should be judged. If this conception is relativistic because of its insistence upon the need for varied and flexible criteria, in another sense it clearly gives an important kind of objectivity to criticism: it means that the *relevancy* of standards is a worthy critical concept.

To illustrate this, consider the endless debates regarding the significance of subject matter in works of art. What is the importance of Christian themes, it is asked, for painting? Do such "ulterior ends" as religious, social, and political subjects add or detract, or are they irrelevant to the total artistic effect? I. A. Richards has an answer to these questions. Few critics realize, he says,

that poetry is of more than one kind, and that the different kinds are to be judged by different principles. There is a kind of poetry into the judgment of which ulterior ends directly and essentially enter; a kind part of whose value is directly derivable from the value of the ends with which it is associated. There are other kinds, into which ulterior ends do not enter in any degree, and there are yet other kinds whose value may be lowered by the intrusion of ends relatively trivial in value.[95]

In this passage Richards distinguishes three kinds of poetry which are best judged by three different principles.

Using painting rather than poetry for illustration, we may

95. *Principles of Literary Criticism* (New York, 1926), p. 77.

say first, there is painting the value of which is partly derived from the value of the theme, e.g., Byzantine painting; second, though rarely, there is painting the value of which is independent of any "ulterior ends," e.g., abstract art; and third, there is painting the value of which is decreased when ends intrude in such a way that complete harmony between subject matter and content is lacking, e.g., much Renaissance painting: thus concerning the banquet scenes by Veronese, one might say either that the given religious subjects are an intrusion upon the contemporary social feasts or that the festive social atmosphere is an intrusion upon the prescribed subjects.

To illustrate further this concept of relevancy, consider the modern humanist who, while rejecting *a priori* values, nonetheless sets up ethical and critical standards which are as inflexible as any imagined by the absolutist. Everyone, he says, ought most highly to value classical forms of art, because these, in stressing reason and self-control, emphasize the most important realms of experience. Must we then agree that the art of Raphael, Poussin, and Ingres is in any definitive way superior to that of El Greco, Rembrandt, and Delacroix? Would we turn to a humanist critic for evaluations concerning the romantics? The relativist answer will be emphatically "no." Or suppose that strikingly divergent types of Chinese and western art objects are being considered. In this case, the principle of relevancy teaches that one may successfully judge each type only on the basis of that criterion which is appropriate and applicable. To appraise the merits of Chinese art on the basis of western criteria, or to appraise the merits of western art on the basis of Chinese criteria, would be indeed unwise. Or again, to cite a specific instance, is it not inevitable that Coomaraswamy and other critics who judge art primarily by its content will be more expert in explaining and evaluating Far Eastern and medieval art but will less successfully understand and appreciate that of the Renaissance and

of today? And conversely, is it not evident that the analyses and appraisals of formalistic critics like Fry and Bell will be better, say, concerning the painting of fifteenth century Italy and worse concerning that of fifteenth century Flanders?

Obviously, however, the relevancy of principles will directly depend upon one's total critical system. Thus the foregoing criticism of Veronese's banquet scenes will be unintelligible to anyone who does not recognize a distinction between subject matter and content, and it will be repudiated as trivial by those who consider the distinction unimportant or who appraise solely by formal standards. Or again, the estimates implied in the preceding paragraph regarding fifteenth century painting in Italy and in Flanders will be unacceptable to those critics who do not evaluate highly both the form of the Italian painting and the content of the Flemish painting. A critic, that is to say, who does not primarily treasure Antonio Pollaiuolo's profile portraits for the organization of their pattern and color, and who does not primarily treasure Rogier van der Weyden's Escorial "Crucifixion" for the profound spiritual expressiveness of Saint John's face, will obviously not agree that formalistic expert critics will be better judges of Italian than of Flemish art. Since, therefore, the application of the relevancy of standards is dependent upon an entire critical system, one should conclude that the most desirable systems are comprehensive in scope. Judged on this basis, the principles of Coomaraswamy and of Fry appear unduly restricted. Yet this kind of limitation, I suggested earlier, affects only the quantitative and not the qualitative value of a critical system. Therefore the diverse principles of Coomaraswamy and of Fry, though applicable, according to my standards, only in judging certain kinds of art, are wholly superior in their somewhat limited way.

(D) "Intentional" and "Qualitative" Evaluation

Let us distinguish between and comment upon two closely related critical principles or types of evaluation which may serve as a useful framework for judicial criticism.[96] First, there is an "intentional" kind of evaluation which investigates the value of the art object in terms of the artist's aim. The critic will inquire: how successfully has the artist fulfilled his purpose? He will search for the motives and procedure of the artist and learn as accurately as possible through knowledge, reflection, intuition, and sympathy what the artist wished to communicate, the critical goal being excellence or perfection in terms of the artist's intent. Such an investigation, we earlier observed, is fraught with difficulties and provides no evidence for the existence of constant and intrinsic values; yet the investigation may succeed to a notable degree, and when it does, it offers the critic a useful and important type of appraisal.

If the critic is making comparative judgments, this intentional ideal will be especially helpful when the objects compared are of the same sort: a Greek original and a Roman copy, a French and a Spanish Gothic tympanum, the "Marriage of the Virgin" by Raphael and by Lo Spagna, or *fêtes galantes* by Watteau and by Lancret. In making such com-

96. The following distinction is analogous to the view of Norman Foerster (quoted on page 76) upon the problem of the suspension of disbelief, and it is discussed by Foerster, in another context, in *American Criticism* (Boston, 1928), pp. 254–256, where he uses the word "quantitative" rather than "intentional." The same distinction is explained as follows by I. A. Richards in *Principles of Literary Criticism*, p. 199: "Sometimes art is bad because communication is defective, the vehicle inoperative; sometimes because the experience communicated is worthless; sometimes for both reasons." Of course many more elaborate and perhaps equally helpful frameworks have been evolved: for example, the categories of T. M. Greene, or those of George Boas who attempts to eliminate critical confusion by three pairs of distinctions: "(a) Art as artistry and art as a work of art; (b) value as instrumental and value as terminal; (c) the point of view of the artist and the point of view of the observer" (*A Primer for Critics*, p. 25).

parisons, the critic will decide upon a common meaning for the word "better"; then, using this intentional meaning (which doubtless will vary slightly from critic to critic and from period to period) as a criterion, he will point to the relative success with which the artists have achieved their several aims, and in this way estimate the works in terms of their approach to perfection—an intentional evaluation.

The second kind of appraisal, which may be called "qualitative," judges the art object in terms of the standards of the critic, who is then asking: what is the value for himself of a work of art? or what is the comparative value of two or more works? Since the discussion of logical relativism, psychological relativism, and the relevancy of standards explained those critical principles which, according to relativism, are most essential to satisfactory qualitative judgments, we may now point to two less inclusive and less authoritative considerations which, however, further elucidate qualitative appraisal. These considerations pertain to comparative evaluations.

(a) Intentional values should temporarily be discounted, since nothing but confusion will result from an attempt to judge relatively between the two different types of value. Suppose, for instance, that a critic wished to evaluate comparatively a Matisse still-life and a Rembrandt biblical scene; suppose, further, that the Matisse receives an intentional grade of ninety-five and a qualitative one of fifty, whereas the less perfect but more profound Rembrandt receives an intentional sixty and a qualitative ninety. Would it not be ill-advised to decide either that the Rembrandt was a finer painting by five points or, as an alternative that, for some reason, the qualitative value should count more heavily than the intentional, or vice versa? Yet even so keen a critic as Daiches commits this fallacy to a degree. In his evaluation of Woolf's *To the Lighthouse,* he maintains—correctly according to his standard—that "this is minor fiction at its most triumphant—minor, because after all it does deal with a

backwater of human experience; triumphant, because it is done so perfectly." [97] I agree; but why does Daiches conclude the same paragraph with the undiscussed pronouncement that "a first-rate minor work is worth many second-rate major ones"? This statement which apparently assumes that a criterion of artistic perfection is decidedly and decisively more valuable than one of artistic significance flatly contradicts, it is worth observing, the verdict of Longinus upon the same problem. After asking: "Is it not worth while, on this very point, to raise the general question whether we ought to give the preference, in poems and prose writings, to grandeur with some attendant faults, or to success which is moderate but altogether sound and free from error?" [98] Longinus concludes: "I do not waver in my view that excellences higher in quality, even if not sustained throughout, should always on a comparison be voted the first place, because of their sheer elevation of spirit if for no other reason." Contrary to these views of Daiches and Longinus, it seems more reasonable to assert that the relative values of artistic perfection and artistic significance cannot profitably be measured. Yet it is evident, if we apply the axiom of logical relativism, that all solutions to the problem at hand depend upon one's basic criteria; and it is also evident, if we apply the axiom of psychological relativism, that one should not claim universal or absolute validity for his own opinion.

(b) Comparative judgments in qualitative, as in intentional value, will be most useful when the objects compared are of the same general kind, e.g., of the same medium. On the basis, let us say, of carefully defined criteria either of triviality versus greatness, or of coarseness and obviousness versus refinement and subtlety, there would be little or no

97. David Daiches, *The Novel and the Modern World* (Chicago, 1939), p. 183. Perhaps, through failure to understand Daiches correctly, my criticism at this point is unjust. So much depends upon the *exact* interpretation one gives to his words (which follow in the text) "many second-rate major ones."

98. *Longinus on the Sublime* (New York, 1930), p. 109. C. S. Baldwin, ed.

sense in attempting qualitatively to compare the "Belleville Breviary" with Chartres Cathedral or a Derain landscape with a Gropius house. On the same basis, however, consider the possible critical education which might result from a qualitative comparison between Giovanni da Bologna's "Mercury" and Bernini's "Longinus" or between a female nude by Maxfield Parrish and one by Renoir. To be sure, the first task of the expert critic in such cases would probably be to analyze the relatively objective properties of each object and to point out differences between those properties of each which can reasonably be compared (e.g., treatment of medium, of three dimensional form, of composition, of movement, and so forth); but, in addition to this fundamental elucidatory task, the critic—*provided* of course he subscribes to a normative standard of artistic significance—should state that and explain why the Bernini and the Renoir appear to be the qualitatively superior works of art. For example, he should stress the greater forcefulness and profundity of Bernini's highly expressive interpretation, and he should dwell upon the comparatively rich organization of design, plastic effects, and color harmonies in the Renoir. Or again (to select an example in which qualitative differences are evidently less marked), if a critic is comparing Rubens' "Rape of the Daughters of Leucippus" in Munich with Delacroix' "Abduction of Rebecca" in New York, he will be wise to explain why, on the basis of his standard of artistic significance, the Rubens both in form and content seems to him the superior work of art. If critics fail to make such appraisals, they have neglected a major function of criticism. That these appraisals in no way concede the case to objectivism should be apparent from the nature of relativist standards and presuppositions.

The foregoing consideration of relativist criteria attempts only to outline their leading traits and to suggest their importance for judicial criticism. My purpose has been to state

briefly, not to argue fully, the several aspects of the subject. In summary: (*A*) We may emphasize the necessity of these criteria for an understanding of specific evaluations, and we may recall, as an aspect of logical relativism, the derivative and tentative character of the standards: they are consciously chosen concepts which, at any time, may be altered in order to meet the requirements of carefully considered critical insights. (*B*) The standards are, to a point, genuinely relative in the sense that differently constituted sorts of better men naturally subscribe to different, yet equally good attitudes, artistic as well as philosophical. Thus in attempting to evaluate relativist principles the critic concludes that differing standards sincerely held by genuine experts cannot profitably be rated; he subscribes to the axiom of psychological relativism. And he claims that disregard for or rejection of this axiom promotes dogmatic, misguided, and misleading criticism. Significant judgments of good and bad, better and worse can be made, however, when the criteria of the expert are compared with those of all incompetent observers; for just as the relativist believes he can distinguish bad men from good, so he believes that artistic concepts vary enormously from types which are extremely crude to those which are highly refined. (*C*) The standards, moreover, must be relevant because, since there are many sorts of art, each kind can be best judged only by one or more standards which are specially appropriate; yet the specific application of this principle of relevancy will depend upon one's whole critical system. In so stressing the significance of relevant empirical criteria and in attempting as far as possible to appraise these, the relativist emphatically renounces the impulsive impressionism of the subjectivist and actually bases his criticism upon a foundation more concrete and empirically objective than that of the absolutist. (*D*) As a feasible framework for artistic appraisals, one may distinguish between (i) intentional evaluation which judges on the basis of the artist's purpose

and which, in respect to comparative judgments, is most useful when the objects compared are of the same sort; and (ii) qualitative evaluation which judges on the basis of the critic's standards and which, in respect to comparative judgments, is most useful when intentional evaluation is discounted and when the objects compared are sufficiently alike to make the appraisals critically fruitful.

To conclude: art criticism is sorely in need of a sound theoretical basis in order to handle satisfactorily the problem of value judgments. A consideration of the three possible major bases has resulted in the following position: "(I) Objectivism errs by supposing that all art can be ranked on a single scale uniform for and discernible by all normal persons; (II) subjectivism errs by supposing that there is no scale common to any two or more persons; (III) relativism teaches that almost any scale can be used for *some* purposes, provided (i) that the theory on which the scale was constructed is made explicit, and provided (ii) that the usefulness of the scale is seen to be proportional to the amount and kind of direct experience of art subsumed under the theory which has created the scale." [99] Stated in another way, my aim has been to show that some reasonable theory must be held which avoids the untenable extremes of objectivism and subjectivism; for neither a critical value theory which adopts ultimate standards nor one which rejects any standard whatsoever is acceptable. An attempt to define precisely a satisfactory third position presents perplexing problems which this essay has treated in a simplified and tentative manner. But the general solution to the difficulty is clear. What is indubitably required is a relativism which comprehends no values apart from human valuations, yet which recognizes the necessity for and justifies the existence of sound judgments of better and worse. These, however, cannot ever be

99. Professor F. Cudworth Flint, in a comment upon the manuscript of this essay.

considered absolute or fixed, for they depend both upon philosophical assumptions and upon empirical criteria which will vary somewhat from individual to individual, from culture to culture. But this only means that an amount of wholesome elasticity and variety is as inevitable and desirable in criticism as it is in human nature.

BIBLIOGRAPHY AND INDEX

SELECTED BIBLIOGRAPHY

The dates given in the bibliography refer to the edition used and not necessarily to the first edition of the work in question. No bibliography for periodical articles is given since full references to these appear in the footnotes.

PART I: PROBLEMS IN MEANING

A. J. AYER, *Language, Truth and Logic,* Oxford University Press, New York, 1936.

—— *The Foundations of Empirical Knowledge,* The Macmillan Company, New York, 1940.

KENNETH BURKE, "Semantic and Poetic Meaning," *The Philosophy of Literary Form,* Louisiana State University Press, 1941.

RUDOLPH CARNAP, *Introduction to Semantics,* Harvard University Press, Cambridge, Mass., 1942.

STUART CHASE, *The Tyranny of Words,* Harcourt, Brace and Co., New York, 1938.

WILLIAM EMPSON, *Seven Types of Ambiguity,* Chatto and Windus, London, 1930.

A. H. GARDINER, *The Theory of Speech and Language,* The Clarendon Press, Oxford, 1932.

S. I. HAYAKAWA, *Language in Action,* Harcourt, Brace and Co., New York, 1941.

WILLIAM JAMES, *The Meaning of Truth,* Longmans, Green and Co., New York, 1932.

ALFRED KORZYBSKI, *Science and Sanity,* Science Press Printing Co., Lancaster, Pa., 1933.

SUSANNE LANGER, *Philosophy in a New Key,* Harvard University Press, Cambridge, Mass., 1942.

I. J. LEE, *Language Habits in Human Affairs,* Harper and Brothers, New York, 1941.

JOHN LOCKE, "Of Words," *An Essay Concerning Human Understanding,* Book III, The Clarendon Press, Oxford, 1894. A. C. Fraser, ed.

C. W. Morris, "Foundations of the Theory of Signs," *International Encyclopedia of Unified Science,* I, 2, The University of Chicago Press, 1938.

T. C. Pollock, *The Nature of Literature,* Princeton University Press, Princeton, 1942.

J. R. Reid, *A Theory of Value,* Charles Scribner's Sons, New York, 1938.

C. K. Ogden and I. A. Richards, *The Meaning of Meaning,* 4th ed., Harcourt, Brace and Co., New York, 1936.

I. A. Richards, *Mencius on the Mind,* Harcourt, Brace and Co., New York, 1932.

———— *Basic Rules of Reason,* Kegan Paul, Trench, Trubner and Co., London, 1933.

———— *Coleridge on Imagination,* Harcourt, Brace and Co., New York, 1935.

———— *The Philosophy of Rhetoric,* Oxford University Press, New York, 1936.

———— *Interpretation in Teaching,* Harcourt, Brace and Co., New York, 1938.

———— *How To Read a Page,* W. W. Norton and Co., New York, 1942.

Bertrand Russell, *An Inquiry into Meaning and Truth,* W. W. Norton and Co., New York, 1940.

Gustaf Stern, *Meaning and Change of Meaning,* Wettergen and Kerbers Förlag, Göteborg, 1932.

W. M. Urban, *Language and Reality,* The Macmillan Company, New York, 1939.

Hugh Walpole, *Semantics,* W. W. Norton and Co., New York, 1941.

Part II: Problems in Evaluation

While all of the subjects in the remainder of this bibliography are closely related, it seems helpful to group them according to subdivisions which, of course, necessarily interlock and overlap. The highly restricted list under section (E) naturally includes only those authors who are conspicuously concerned with value judgments.

(A) PHILOSOPHICAL THEORIES

SAMUEL ALEXANDER, *Beauty and Other Forms of Value,* Macmillan and Co., Ltd., London, 1933.

JOHN DEWEY, "Theory of Valuation," *International Encyclopedia of Unified Science,* II, 4, The University of Chicago Press, 1939.

A. C. GARNETT, *Reality and Value,* Yale University Press, New Haven, 1937.

DAVID HUME, "Of the Standard of Taste," *Essays,* I, Longmans, Green and Co., London, 1882. T. H. Green and T. H. Grose, eds.

IMMANUEL KANT, "Critique of Judgement," *Selections,* Charles Scribner's Sons, New York, 1929. T. M. Greene, ed.

WOLFGANG KÖHLER, *The Place of Value in a World of Facts,* Liveright Publishing Corporation, New York, 1938.

JOHN LAIRD, *The Idea of Value,* The University Press, Cambridge, England, 1929.

R. B. PERRY, *General Theory of Value,* Longmans, Green and Co., New York, 1926.

J. R. REID, *A Theory of Value,* Charles Scribner's Sons, New York, 1938.

(B) STUDIES IN TASTE

RUTH BENEDICT, *Patterns of Culture,* Houghton Mifflin Co., Boston, 1934.

F. P. CHAMBERS, *Cycles of Taste,* Harvard University Press, Cambridge, Mass., 1928.

——— *The History of Taste,* Columbia University Press, New York, 1932.

JOAN EVANS, *Taste and Temperament,* The Macmillan Company, New York, 1939.

E. E. KELLETT, *The Whirligig of Taste,* The Hogarth Press, London, 1929.

——— *Fashion in Literature,* George Routledge and Sons, London, 1931.

JOHN STEEGMANN, *The Rule of Taste,* Macmillan and Co., Ltd., London, 1936.

(C) HISTORICAL STUDIES IN CRITICISM AND ESTHETICS

ANTHONY BLUNT, *Artistic Theory in Italy,* The Clarendon Press, Oxford, 1940.

BERNARD BOSANQUET, *A History of Aesthetic,* The Macmillan Company, New York, 1934.

E. F. CARRITT, *Philosophies of Beauty,* Oxford University Press, London, 1931.

K. E. GILBERT and HELMUT KUHN, *A History of Esthetics,* The Macmillan Company, New York, 1939.

ANDRÉ FONTAINE, *Les Doctrines d'Art en France,* Paris, 1909.

M. M. RADER, *A Modern Book of Esthetics,* Henry Holt and Co., New York, 1935.

J. C. RANSOM, *The New Criticism,* New Directions, Norfolk, Conn., 1941.

GEORGE SAINTSBURY, *A History of English Criticism,* Dodd, Mead and Co., New York, 1911.

J. E. SPINGARN, *A History of Literary Criticism in the Renaissance,* Columbia University Press, New York, 1938.

LIONELLO VENTURI, *History of Art Criticism,* E. P. Dutton and Co., New York, 1936.

—— *Art Criticism Now,* The Johns Hopkins Press, Baltimore, 1941.

(D) CRITICAL AND ESTHETIC THEORY

Works which present theories before the 20th century are not listed here regardless of their importance. References to these works may of course be found in such studies as those of Saintsbury and Bosanquet which are listed in section (C) of the bibliography.

WALTER ABELL, *Representation and Form,* Charles Scribner's Sons, New York, 1936.

E. M. BARTLETT, *Types of Aesthetic Judgment,* George Allen and Unwin, London, 1937.

GEORGE BOAS, *A Primer for Critics,* The Johns Hopkins Press, Baltimore, 1937.

MAUD BODKIN, *Archetypal Patterns in Poetry,* Oxford University Press, London, 1934.

BERNARD BOSANQUET, *Three Lectures on Aesthetic*, Macmillan and Co., Ltd., London, 1931.

AUGUSTO CENTENO, ed., *The Intent of the Artist*, Princeton University Press, Princeton, 1941.

A. R. CHANDLER, *Beauty and Human Nature*, D. Appleton–Century Co., New York, 1934.

R. G. COLLINGWOOD, *The Principles of Art*, The Clarendon Press, Oxford, 1938.

BENEDETTO CROCE, *Aesthetic*, Macmillan and Co., Ltd., London, 1909. Douglas Ainslie, trans.

JOHN DEWEY, *Art as Experience*, Minton, Balch and Co., New York, 1934.

NORMAN FOERSTER, *American Criticism*, Houghton Mifflin Co., Boston, 1928.

HENRI FOCILLON, *The Life of Forms in Art*, Yale University Press, New Haven, 1942. C. B. Hogan and George Kubler, trans.

ROGER FRY, "An Essay in Aesthetics," *Vision and Design*, Brentano's, New York.

——— "Some Questions in Esthetics," *Transformations*, Brentano's, New York, 1926.

T. M. GREENE, *The Arts and the Art of Criticism*, Princeton University Press, Princeton, 1940.

LOUIS GRUDIN, *A Primer of Aesthetics*, Covici, Friede, New York, 1930.

HENRY HAZLITT, *The Anatomy of Criticism*, Simon and Schuster, New York, 1933.

T. E. HULME, *Speculations*, Harcourt, Brace and Co., New York, 1924.

D. G. JAMES, *Scepticism and Poetry*, George Allen and Unwin, London, 1937.

H. N. LEE, *Perception and Aesthetic Value*, Prentice-Hall, New York, 1938.

F. J. MATHER, JR., *Concerning Beauty*, Princeton University Press, Princeton, 1935.

R. M. OGDEN, *The Psychology of Art*, Charles Scribner's Sons, New York, 1938.

O. A. H. PELL, *Value-Theory and Criticism*, Ph. D. Thesis, Columbia University, New York, 1930.

S. C. Pepper, *Aesthetic Quality*, Charles Scribner's Sons, New York, 1937.

F. A. Pottle, *The Idiom of Poetry*, Cornell University Press, Ithaca, 1941.

D. W. Prall, *Aesthetic Judgment*, Thomas Y. Crowell Co., New York, 1929.

Herbert Read, *The Meaning of Art*, Faber and Faber, London, 1935.

C. K. Ogden, I. A. Richards and James Wood, *The Foundations of Aesthetics*, George Allen and Unwin, London, 1922.

I. A. Richards, *Principles of Literary Criticism*, Harcourt, Brace and Co., New York, 1926.

Michael Roberts, *Critique of Poetry*, Jonathan Cape, London, 1934.

Elisabeth Schneider, *Aesthetic Motive*, The Macmillan Company, New York, 1939.

W. T. Stace, *The Meaning of Beauty*, The Cayme Press, London, 1929.

D. A. Stauffer, ed., *The Intent of the Critic*, Princeton University Press, Princeton, 1941.

Leo Stein, *The A-B-C of Aesthetics*, Boni and Liveright, New York, 1927.

Austin Warren, "Literary Criticism," *Literary Scholarship*, University of North Carolina Press, 1941.

(E) CRITICAL PRACTICE

Bernard Berenson, *The Italian Painters of the Renaissance*, Revised ed., The Clarendon Press, Oxford, 1930.

―――― *The Drawings of the Florentine Painters*, The University of Chicago Press, Chicago, 1938.

David Daiches, *The Novel and the Modern World*, The University of Chicago Press, Chicago, 1939.

―――― *Poetry and the Modern World*, The University of Chicago Press, Chicago, 1940.

T. S. Eliot, *Selected Essays*, Harcourt, Brace and Co., New York, 1932.

Roger Fry, *Vision and Design*, Brentano's, New York.

―――― *Transformations*, Brentano's, New York, 1926.

———— *Cézanne,* The Macmillan Company, New York, 1927.

———— *Last Lectures,* The Macmillan Company, New York, 1939.

T. M. GREENE, *The Arts and the Art of Criticism,* Princeton University Press, Princeton, 1940.

F. J. MATHER, JR., *Estimates in Art,* 1st series, Charles Scribner's Sons, New York, 1916.

———— *A History of Italian Painting,* Henry Holt and Co., New York, 1923.

———— *Venetian Painters,* Henry Holt and Co., New York, 1936.

———— *Western European Painting of the Renaissance,* Henry Holt and Co., New York, 1939.

I. A. RICHARDS, *Practical Criticism,* Kegan Paul, Trench, Trubner and Co., London, 1929.

EDMUND WILSON, *Axel's Castle,* Charles Scribner's Sons, New York, 1936.

INDEX

When references mention both artist or author and one of his works, only the artist or author is usually indexed.